Kent
Britain's Frontline County

Clive Holden

AMBERLEY

Maps of Kent and Medway adapted from d-maps.com:
Kent: http://d-maps.com/carte.php?&num_car=96490&lang=en
Medway: http://d-maps.com/carte.php?&num_car=98534&lang=en

First published 2017

Amberley Publishing
The Hill, Stroud
Gloucestershire, GL5 4EP

www.amberley-books.com

British Library Cataloguing in Publication Data.
A catalogue record for this book is available from the British Library.

ISBN 978 1 4456 5518 5 (print)
ISBN 978 1 4456 5519 2 (ebook)

Origination by Amberley Publishing.
Printed in the UK.

Contents

Introduction

The county of Kent has always been considered Britain's 'front line'. Situated as it is on the extreme south-eastern corner of England, it is the closest point to continental Europe and thus the most vulnerable to invasion.

Although some immigrants had arrived in Kent from Gaul and Flanders as early as 500 BC, these incursions had been largely peaceful and met with virtually no resistance and the newcomers soon integrated into local society.

By 100 BC the westward expansion of the Roman Empire had forced many members of ancient European tribes such as the Franks and Visigoths from their homelands in search of a life free from Roman domination. Many of them crossed the channel to Kent, where the existing population was prompted to establish a number of armed defensive camps, often on hilltops, to resist the influx of the foreign hordes. Evidence of these ancient hill forts can still be seen at Oldbury and Bigbury.

By 55 BC the Romans had set their eyes on Britain and the first expedition under Julius Caesar landed near Dover in late summer that year to be met with fierce resistance. The British had been forewarned of the Roman assault by foreign merchants, who had witnessed the invasion force in its embarkation port (probably Boulogne) and had mobilised their forces accordingly. However, the invaders eventually prevailed and set up camp where they stayed until the outbreak of winter. Further Roman expeditions followed over the next ninety-eight years, many of them arriving through the fortified port they had built at Richborough, the remains of which can still be seen today. These much larger expeditions finally resulted in the conquest of Britain in AD 43 and the establishment of formal Roman rule, which was to last for more than 350 years.

After the Romans withdrew, around AD 410, the indigenous British tribes and their homeland were left virtually defenceless. News of the Roman withdrawal and the resulting weakness of the Britons soon reached the tribes of mainland Europe. It was not long before these tribes were once again crossing the Channel in search of new lands and riches. In 455 the Germanic brothers Hengist and Horsa led an army of Jutes, Angles and Saxons against the Britons who now served under the Welsh warlord Vortigern. The two armies met at the River Medway near the village of Aylesford. Following the Battle of Aylesford, in which Horsa was killed, Hengist became the first King of Kent.

The Jutes continued to rule Kent until 616, by which time their realm had spread to include most of the country south of the Humber. With this expansion of territory, the power of Kent began to decline and by 825 it had been absorbed into the kingdom of Wessex.

In 850 Viking warriors under the Danish chieftain Rorick landed on Thanet, from where they attacked Canterbury and London and spent that winter on Sheppey and Thanet. Alfred the Great, King of Wessex, constructed a number of forts to repel the Viking invaders including Bayford Castle, Tonge Castle and Castle Rough, which together defended the Swale and Milton Creek.

In 892 a force of around 7,000 Vikings sailed from Boulogne and landed near Bonnington in Kent, destroying the fort there. Alfred gathered his troops at Newenden and from there drove the Danes back to their longboats, forcing them to return to France.

After the Norman Conquest of 1066 came a period of extensive stone castle-building as William I sought to tighten his grip on his new realm and overawe its subjects, who had never before seen such fearsome-looking structures. Castles were built at Dover, Canterbury and Rochester that defended the old Roman Road route, which was still the main line of communication to London. Other minor castles followed elsewhere in the county, including those at Tonbridge, Leeds and Allington.

Of all the Norman castles, Dover was the most formidable, sitting high up on the cliffs and dominating the town and beaches below. Its power reflected its situation as the country's closest point to the continent and therefore most vulnerable to invasion. This geographical fact was the reason why Dover continued to be so heavily fortified for the next 900 years.

Throughout the medieval period, more castles and grand fortified houses sprang up around the county. Some were more for the protection of the owners from their rebellious serfs than from any foreign invader, but in 1345 tensions with France saw the county's defences readied for invasion. It was around this period that saw the development of gunpowder and cannon, which made many smaller castles obsolete as their walls were unable to withstand the slightest bombardment from these powerful new weapons. Of course, artillery was not for the sole use of the attacker and the ramparts of the more militarily significant larger castles began to mount guns as a means of defence.

The reign of Henry VIII saw the break with the Church of Rome and the Dissolution of the Monasteries, which brought Britain under threat from the joint might of France and the Holy Roman Empire. To counter this threat Henry ordered a chain of new fortresses to be constructed along the coast from Cornwall to Hull. These new defences were designed specifically to house the latest artillery pieces with purpose-built gun emplacements and rounded walls to deflect shot from enemy canon. Fine examples of these can still be seen in Kent at Deal, Walmer and Sandgate.

Henry VIII had also been responsible for the establishment and development of the Royal Navy and in 1547, the last year of his reign, a large storehouse was rented alongside the River Medway at Chatham to store ropes, masts and other equipment of the royal warships that had, for some years, been using the river as a safe anchorage during the winter months. The acquisition of this building marked the genesis of one of the nation's greatest and most important naval dockyards. In subsequent years, the facilities were expanded to cover an area that was later to be known as the Gun Wharf and by the 1570s it had been fully established as a royal dockyard. By 1613 the dockyard had outgrown its original location, so an area of around 80 acres was acquired to the

north of the old yard. Dry docks, wharves, cranes, a sail loft, ropehouse and officers' residences were built here between 1619 and 1626, by which time the new yard was fully operational. By the end of the century it extended to an area covering most of what is now the site of Chatham Historic Dockyard.

Although Chatham Dockyard had grown in size and importance by the mid-seventeenth century, little had been done to upgrade its defences. Upnor Castle had been built alongside the Medway opposite the dockyard in the 1560s as a result of increased fears of a French invasion, but within 100 years the castle, although still garrisoned, had fallen into neglect and disrepair, along with most of the Medway's defences. In 1667 the Dutch Navy launched an audacious raid on the Medway. They made a preliminary attack on an uncompleted fort at Sheerness and made their way unopposed upriver towards Chatham where the British fleet lay at anchor far from the cover of the obsolete cannon of Upnor Castle. The Dutch fell upon the British ships, burning and sinking several before carrying away the pride of the fleet, the *Royal Charles*.

The raid sent shockwaves through the country and King Charles II ordered the defences of the Medway to be upgraded and strengthened. Among the defensive improvements, two new artillery forts were built opposite each other downriver from the dockyard at Gillingham and Cockham Wood, the idea being to prevent enemy ships reaching the Dockyard. By 1668 Upnor Castle itself was declared obsolete and converted into a powder magazine, becoming the predecessor of what was to become the Upnor Ordnance Depot.

Throughout the eighteenth and nineteenth centuries there were tensions with France, particularly after the French Revolution and the rise of Napoleon, when there were genuine fears of invasion. Prior to this, much work had already been done to strengthen the landward defences of Chatham Dockyard with the construction of a series of ditches and fortifications that stretched from Gillingham to Rochester, which became known as the Chatham Lines.

At Dover, concerns were raised that the castle and harbour could be vulnerable. If the French landed further along the coast and advanced inland, they could outflank the town's incomplete defences on the Western Heights. With the eventual outbreak of war in 1804, work on these defences was accelerated and by 1815 the construction of two powerful new artillery forts, linked by a series of ditches, was complete. Further west, a chain of artillery towers was built along the coast between Folkestone and St Mary's Bay.

The need to upgrade the facilities for the Royal Navy during this period saw the royal dockyard at Sheerness, along with its defences, also undergoing major rebuilding and modernisation.

In 1860, a royal commission reported serious weaknesses in the nation's defences and, as tensions with France were still high, a huge programme of new works was quickly initiated. At Chatham, the Lines were supplemented with an outer ring of forts to counter the increased range of artillery. Further forts were built on the Hoo Peninsula between Grain and Cliffe to defend the lower Thames and the Medway estuary. At Dover, new coastal batteries were built, the Western Heights fortifications strengthened, and a new fort constructed to the north of the castle. By the time all these new fortifications were completed in the 1890s, many of them had already been rendered obsolete by further advances in the power of artillery and many of the forts never even mounted the guns that they had been designed for.

Fears of any French invasion subsided with the signing of the Entente Cordiale agreements in 1904. Imperial Germany was now the new threat, and with Kaiser Wilhelm II intent on a policy of colonial expansion and the building of a High Seas Fleet powerful enough to challenge the Royal Navy, Britain's politicians and service chiefs were soon considering the possibilities of war with Germany.

With the advent of powered flight in the early years of the twentieth century came the potential of adding a new dimension to warfare. In 1910 the Royal Navy accepted an invitation from the Royal Aero Club, based at Eastchurch on Sheppey, to use their airfield as a training ground for pilots. At the outbreak of the First World War the Royal Navy assumed responsibility for the air defence of Great Britain while the Army's Royal Flying Corps supported the Expeditionary Force in France. During the war, many new airfields were opened around Kent including Detling, Biggin Hill and Manston, the latter two coming under the command of the newly formed RAF in 1918.

Although the main focus of the war on land was in France, there were still very real fears of German landings in Kent. The Isle of Sheppey became a heavily defended military zone, as did Medway and Dover. Air raids were also a threat and the first anti-aircraft gun batteries were installed to defend the Royal Navy's Ordnance Depot at Lodge Hill.

Following the end of the war, budgets for all three services were cut and millions of men were demobilised and returned to civilian life. Many of the batteries and fortifications in Kent were deactivated or demolished; airfields were converted to civilian flying or returned to agricultural use. Thousands of workers at Chatham and Sheerness Dockyards were made redundant as the Royal Navy dramatically reduced the size of the fleet.

Cuts in defence continued throughout the 1920s into the early 1930s. In 1933, Adolf Hitler and the Nazi party came to power in Germany, intent on restoring the territory lost as a result of the 1919 Treaty of Versailles. Over the next few years tensions rose, and as nations fell under the Nazi yoke, the British government began rearming and preparing for war. When war eventually broke out in 1939 the country was still far from ready to thwart any German invasion. More airfields were hurriedly taken over by the RAF, including the one at West Malling. The existing coastal gun batteries had to be upgraded and new 'Emergency Batteries' constructed along Kent's coastline, such as the one at St Margaret's Bay near Dover.

The Royal Naval barracks at Chatham were soon full to capacity as reservists were recalled and new recruits arrived for basic training before being deployed on ships or to shore bases in the Nore Command. The Royal Navy and Army also took over and expanded the Napoleonic-era tunnel system under Dover Castle, from where they co-ordinated the channel defences

Thanks to the RAF's victory in the Battle of Britain, the German invasion was cancelled, but air raids (and later the infamous German V-1 and V-2 rocket attacks) continued, keeping the fighter squadrons and anti-aircraft batteries busy until the end of the war in 1945.

The post-war years saw reductions in the defence establishment in Kent as it adapted to the 'Nuclear Age'. Although the Army vacated Dover Castle in the late 1950s, the underground-tunnel system continued to be maintained ready for use as regional seat of government in the event of a nuclear attack.

The end of the Cold War in 1991 was the signal for more extensive cuts in defence expenditure, which had a deep effect on the armed forces in Kent. Chatham Naval Base

had already closed in 1984, leaving no permanent Royal Navy presence in the county. The RAF vacated its last base at Manston in 1999, although it still retained a military use with the Defence Fire Training and Development Centre occupying part of the site.

At the time of writing, just a handful of Army barracks remain in what used to be known as 'Fortress Kent'. Many of the old military sites have been demolished and redeveloped while others have been found new uses and continue to thrive. Traces of some sites can only now be found underground while others still survive and are either looked after as tourist attractions or have been sadly left to slowly decay. Attempts have been made to restore some of latter with several groups of enthusiastic volunteers actively working on various projects around the county.

With this book I've sought to bring to the reader's attention some of the less well-known military sites in Kent. Many of them are publicly accessible but others are closed off, either for safety reasons or because they are on private property. However, all of them remain as important reminders of Kent's rich military heritage and its role over the centuries as Britain's 'frontline county'.

Clive Holden
September 2016

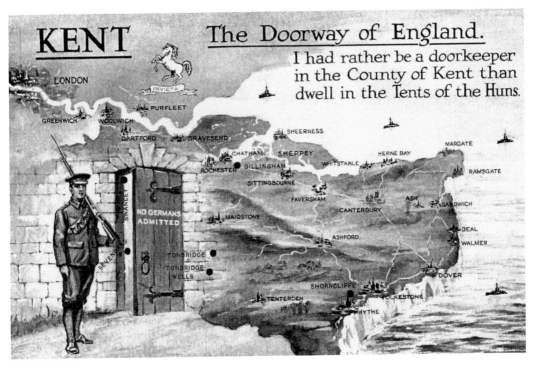

First World War postcard.

Glossary of Military and Fortification Terms

As some of the terminology used in this book is technical in nature, particularly in regard to fortifications, much of which is derived from the French language, I have included this general glossary, which the reader may find helpful.

Barbette: Gun mounted on a free-standing carriage behind ramparts.
Barracks: A building providing accommodation for soldiers.
Bastion: Projection from the general outline of a fortress from which the defenders can see and give flanking fire to the ground in front of the ramparts.
Battery: A position for mounting a number of guns, usually all with a similar field of fire.
Blockhouse: A small, fortified barrack.
Boom: A removable floating barrier to close a channel to shipping.

Cannon: A large, heavy piece of artillery, typically mounted on wheels, that fires heavy projectiles. Cannon include guns, howitzers, and mortars.
Caponier: Covered passage within a ditch of a fort either for sheltering communication with the outworks or for providing flanking fire in the ditch.
Carronade: A naval gun of short barrel and large bore produced by the Scottish Carron Iron Co.
Casemate: Bombproof vault, usually arched, providing an emplacement for a gun.
Counterscarp: The outer side of a ditch.
Couvre-porte: A defendable gateway.
Covered way: A protected communication road/path, usually around the works of a fortress on the outer edge of the ditch, protected from enemy fire by earthworks.
Curtain, curtain wall: Portion of a wall or rampart which connects two adjacent positions.

Drawbridge: A moveable wooden bridge that can be raised towards a gateway by means of chains or ropes attached to its outer end.

Embrasure: An opening in a thick wall for a door or window, especially one with sides angled so that the opening is larger on the inside of the wall than on the outside, usually a flared opening for a gun in a wall or parapet.

Expense magazine: A magazine, usually attached to a battery containing additional ammunition to resupply the guns quickly.

Flank: Part of a fort constructed at an angle to the general line in order to command the ground before the latter by side or flanking fire.

Garrison: The troops stationed at a particular place for its defence.
Glacis: Parapet of the covered way, extended in a long slope to meet the natural surface of the ground.
Gorge: Rear of a defensive work, whether open or closed.

Haxo Casemate: Casemate built into a rampart singly or in pairs to protect a gun enclosure.
Hornwork: A defensive outwork consisting of a pair of demi-bastions with a curtain wall connecting them and with two long sides directed upon the faces of the bastions, or ravelins of the inner fortifications, so as to be defended by them. Often used to prevent the enemy occupying an area of high ground or simply strengthen the overall fortifications in the expected direction of attack.
Howitzer: A cannon that combines certain characteristics of guns and mortars. The howitzer delivers projectiles with medium velocities, either by low or high trajectories.

Keep: The main tower within the walls of a medieval castle or fortress

Lines: A system of regular defensive earthworks.
Loopholes: Openings through which a musket or rifle can be fired.

Magazine: A building to store ammunition.
Mortar: A muzzle-loading cannon having a short barrel and relatively wide bore that fires low-velocity shells in high trajectories over a short range.
Motte: A natural or man-made mound on which a castle was erected.
Musket: A long-barrelled muzzle-loading shoulder gun used between the sixteenth and mid-nineteenth centuries by infantry soldiers.

Outworks: All the works constructed beyond the main body of a fortification such as ravelins, covered ways, etc.

Palisade: A wall or fence, usually of sharpened logs, used as a fortification. Usually atop a rampart.
Palisade fence: Iron-railed spike-topped fence designed to be unclimbable.
Parapet: A raised wall or screen at the top of a fortification protecting troops from enemy fire and observation.
Platform, Gun Platform: Floor on which the cannon in a battery are placed.

Rampart: A mass of excavated earth on which the troops and guns of the garrison are elevated, usually associated with a ditch.

Ravelin: A triangular fortification or detached outwork, located in front of the inner works of a fortress. The edges of the ravelin are placed so that the guns there can sweep fire upon the attacking troops as they approach the curtain. The wall facing the inner fortifications is low and designed so that it will not provide shelter to attacking forces in case the ravelin is overtaken by the attackers or abandoned by the defenders.

Redoubt: Small enclosed work without flank defence from its own parapet, often forming a final strongpoint for the defenders.

Revetting: Lining a ditch wall with bricks or wood to strengthen it and to make it more regular.

Rifle: A firearm with a rifled bore, designed to be fired from the shoulder.

Rifling: Spiral grooves cut within a gun barrel to improve accuracy.

Salient: Angled defensive work jutting out from the main fortification.

Sally-port: Subsidiary gate or opening which serves as a communication or egress for troops engaged in a sally.

Scarp: The side of a ditch cut nearest to and immediately below a rampart.

Spur: Outwork consisting of two faces forming a salient angle.

Tenaille: A raised area to protect an exposed area of wall.

Terreplein: Surface of a rampart behind the parapet where guns are mounted.

Transverse: Mound of earth or wall thrown up to stop enfilading fire along any line of work which is vulnerable to it.

Map

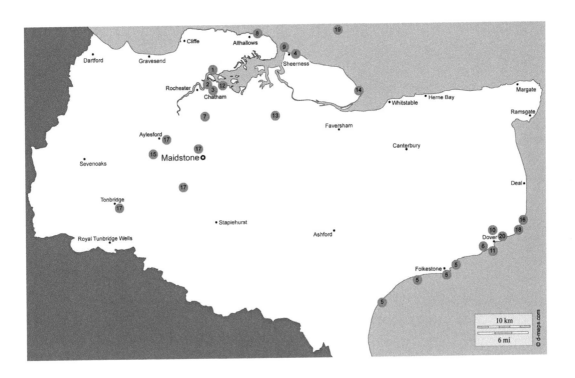

1. Cockham Wood Fort
2. Chatham Gun Wharf
3. Chatham Lines
4. Sheerness Dockyard
5. Martello Towers
6. Drop Redoubt
7. Fort Horsted
8. Slough Fort
9. Garrison Point Fort
10. Fort Burgoyne
11. St Martin's Battery
12. HMS *Pembroke* – Chatham
13. RAF Detling
14. Shellness Defences
15. RAF West Malling
16. St Margaret's Battery
17. River Medway GHQ Line
18. South Foreland Battery
19. Red Sands Sea Fort
20. Dover Castle Combined HQ / Regional Seat of Government

Chapter 1

Cockham Wood Fort

Cockham Wood Fort was built in 1669 on the left bank of the River Medway near Upnor Castle. It was constructed as a direct result of the Dutch raid on the Medway in 1667. The raid was a humiliating defeat for the Royal Navy with the loss and capture of several of its ships, including the flagship the *Royal Charles*, which was towed back to Holland. The Dutch were only prevented from directly assaulting and seizing the Royal Dockyard at Chatham by the English commanders' decision to sink several of their own ships in mid-channel, thus blocking the further progress of the enemy's vessels.

The fort's purpose was to defend Chatham Dockyard from a similar future seaborne attack. It was built to a design by Sir Bernard De Gomme (ironically Dutch-born), who was Charles II's chief engineer. The fort was built into the hillside along the river and the construction took around five months at a cost of around £2,000. When completed it was bastion-shaped and consisted of an upper and lower battery on two tiers, housing twenty and twenty-one guns respectively. Such was the shortage of funds available for spending on the fort that some of these guns could only be provided by removing them from the existing batteries at Upnor and Cooling castles. The rear of the fort comprised a projective fortification known as a ravelin and a 30-foot-high three-storey guard tower and strongpoint, also known as a redoubt. The fort was further protected by earth ramparts and a 50-foot-wide dry ditch. The entrance was at ground level on the eastern side of the fort, complete with a small guardhouse. In the redoubt, an internal staircase gave access to the roof, which was provided with a number of gun positions for the use of light artillery pieces. The ground floor of the redoubt provided space for stores and ammunition and the second floor housed temporary living accommodation for the men. The use for the first floor remains unknown.

The only permanent accommodation provided was a house for the master gunner, situated near the fort's entrance, with the rest of the fort's complement being drawn from the barracks at nearby Upnor Castle. The first recorded master gunner in residence was Simon Penge in 1689.

A similar fort was built opposite on the right bank of the river at Gillingham, but no trace of this fort now remains. The plan was that the fort at Gillingham would be the first to engage any hostile ships sailing up the river. When they entered Gillingham Reach, they would then be engaged by the Cockham Wood batteries while those at Gillingham Fort continued to rake them from the rear.

By the 1690s, the fort was already in need of repairs, including the rebuilding of the embrasures of both gun batteries as well as renovations to the master gunner's house. At the same time, a wooden palisade was set into the riverbank around 20 feet from the Lower Battery to provide some additional defence against assault from the river.

The fort's condition deteriorated through the eighteenth century but in 1715 it was recorded that it still housed a caretaker garrison consisting of the master gunner and four men. However, by the mid-1700s this had been reduced further to just the master gunner and one man. By 1766 the fort had become so rundown that all but the tower building was in need of extensive repair and its artillery armament had been reduced to just one 6-pounder.

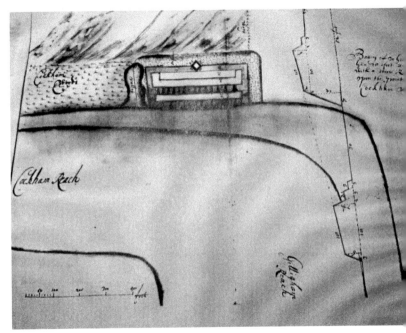

Right: Sketch map from around 1700 showing the location of Cockham Wood Fort.

Below: View of the fort from the right bank of the Medway.

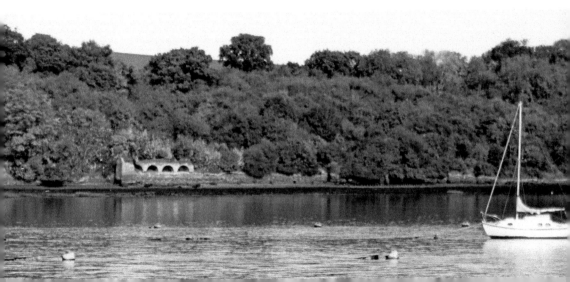

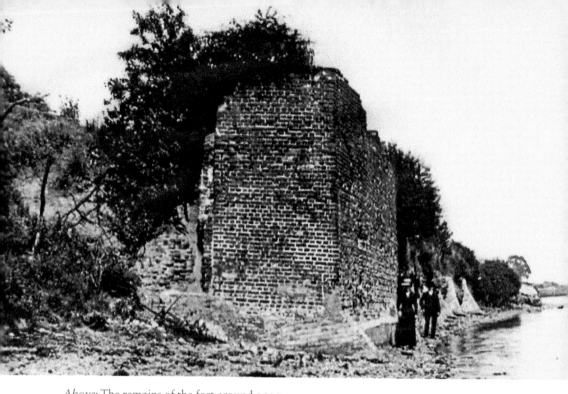

Above: The remains of the fort around 1920.

Below: Looking eastwards along the river frontage of the fort.

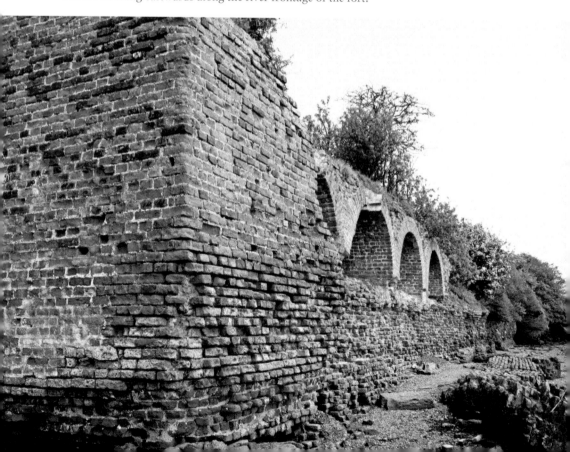

As late as 1794, the Royal Engineers reported that, if necessary, the fort could be repaired enough to mount six guns in an emergency. Materials were even set aside for this purpose at Chatham Dockyard, but were soon stolen. Due to the insanitary conditions at the fort, the last man left around 1797, leaving just the master gunner on-site in his house. The master gunner's house fell out of use by 1806 and he was then accommodated in a new two-storey brick building along with an invalid gunner.

Cockham Wood Fort and Gillingham Fort were both eventually auctioned off for leasehold by the Board of Ordnance in 1818 with a clause that they would revert to the Crown if ever the situation demanded. In 1825, the land around the fort began to be excavated to provide materials for the building of defences at Sheerness, leaving it prone to flooding.

Damage from erosion by the tidal waters of the river and landslides continued to affect the fort and all that remains now is some of the brickwork from the Lower Battery and one wall of the guardhouse on the eastern side. Unfortunately, there are no plans for restoration and so it will continue to be allowed to deteriorate gracefully until the Medway eventually and inevitably sweeps all trace of it away.

The remains of the fort are easily accessible today by means of a walk of just over a mile along the foreshore of the Medway from Lower Upnor, although this should only be attempted at low-tide.

The remains of the Lower Battery.

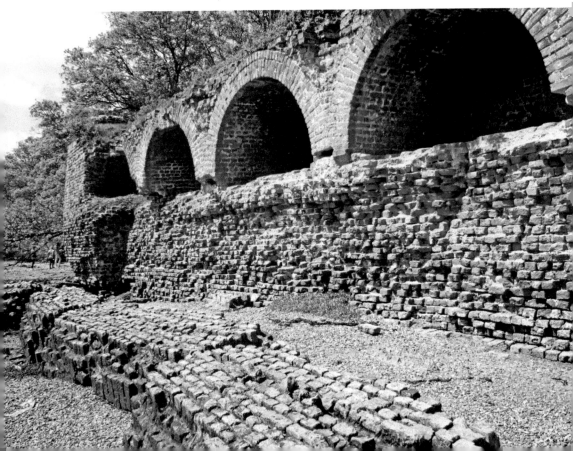

Chapter 2

Chatham Gun Wharf

Chatham Gun Wharf was established on the site of the original Tudor naval dockyard after that moved northwards in 1613 to the larger site we now know as the Chatham Historic Dockyard.

The original Gun Wharf was run by the Board of Ordnance. Ships would dock here to unload cannon, munitions, sidearms, stores and other equipment. These would be housed in the wharf's large storehouses, ready for use by the forts and batteries of the Chatham Lines in time of war. Vessels undergoing maintenance at Chatham Dockyard would also deposit their cannon and other arms into the wharf's storehouses while they were out of service. The senior officer of the Gun Wharf was the chief storekeeper, who was housed in a fine Queen Anne-style house built in the early eighteenth century. The storekeeper held a very important role and was in a position to amass a considerable personal wealth through the manipulation of government contracts – this on top of his already generous salary, which by 1808 was £500 per year, plus £120 allowances (total equivalent in 2016 of almost £40k per annum), plus his large house and a servant, all paid for by the board.

The construction of further impressive buildings followed, including the Grand Store in 1705 and the huge gun carriage shed around fifty years later. One of the few contemporary accounts of the activity at the Gun Wharf in this period was from the famous Kentish historian Edward Hasted, who wrote in 1790:

> The guns belonging to the royal shipping in this river are deposited on this wharf in long tiers and large pyramids of cannon-balls are laid on it, ready for service; there is likewise a continued range of storehouses, in which are deposited the carriages of the guns, and every other kind of store, usually under the care of this office; in one of them is a small armoury of muskets, pistols, cutlasses, pikes, pole-axes and other hostile weapons arranged in proper order.

Following its disastrous performance in the Crimean War, in 1855 the Board of Ordnance was disbanded and its duties transferred to the War Department. In the 1860s the northern part of the Gun Wharf site, from the defensive barrier ditch to the boundary with the Royal Dockyard, was transferred to the Admiralty, while the remainder was retained by the War Department.

The Navy Gun Wharf, with its Grand Storehouse, stored cannon and munitions for use on HM ships, while the Army Gun Wharf (also known as the New Gun Wharf) continued in use as an arsenal for the forts. The Dockyard Railway also serviced the entire Gun Wharf, running through a guarded gateway in the boundary wall. As well as storehouses, both sites were equipped with steam cranes, workshops, smithies, carpenters' shops and offices.

Both wharves continued in use through until the mid-twentieth century with the Army storing clothing and other personal equipment there during the Second World War. Some very secret work was also carried out at the Army Gun Wharf from the mid-1940s. The Royal Army Ordnance Corps (RAOC) Research and Development Centre moved there in March 1946, and it was renamed the RAOC Field Test Centre. It was also an outstation of the Chemical Inspectorate, Woolwich Arsenal. This organisation was later incorporated into the UK Atomic Energy Authority (UKAEA) with some of the Gun Wharf buildings leased to the Atomic Energy Research Establishment from the 1950s. They continued to be used by them until 1966, seven years after the government had sold the Gun Wharf and the adjoining Royal Marine Barracks off to Chatham Borough Council.

Most of the buildings were demolished in the 1960s, including the magnificent Grand Store on the Navy Wharf, to be replaced by new council offices and the Gun Carriage House on the Army Wharf to make way for a car park. However, a few notable buildings do survive to this day, one being the Storekeepers House, the oldest surviving building, which dates from around 1719. In 1863 the building was the Naval Senior Ordnance Officer's Quarters. Now it is the Command House public house.

The Storekeeper's House today.

The Ordnance Store.

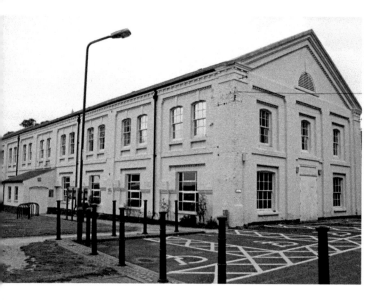

The Smithery & Fitters'
Shop, which dates from
the late nineteenth century
and now houses Chatham
Library.

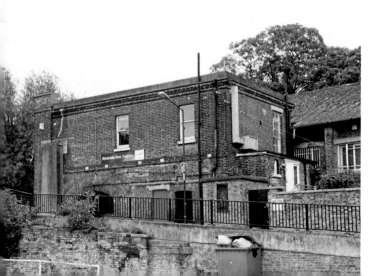

The Police Post guarded the
entrance to the Gun Wharf
from Dock Road. It is now
used as offices by Medway
Council.

The Ordnance Store was built around 1805 for the receipt and issue of all kinds of ordnance from naval ships, including cannonballs, muskets, gun carriages and clothing among other materiel. In 1851, the northern wing was used for 'the binding of carriages' and the southern end as a carpenters' and wheelers' shop. In the late nineteenth century it was an armoury for the storage and repair of small arms and continued as such until the 1950s, when it was leased to the AERE (see above). It is now used by the local Royal Air Force Association and a martial arts club.

Another fine building is the Smithery and Fitters Shop, which dates from the late nineteenth century and now houses Chatham Library.

There is general public access to the whole Gun Wharf area now and it provides a popular walkway along the riverside.

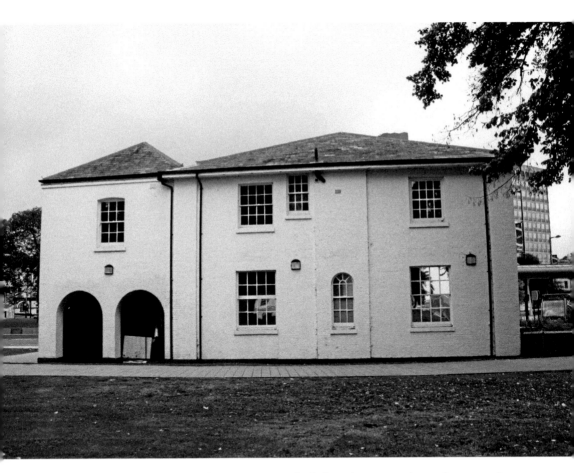

The Army Chief Ordnance Officer's Quarters, which dates from 1815, is now known as the White House and is also used as offices by Medway Council.

Chapter 3

Chatham Lines

With tensions with France increasing in the early eighteenth century, the decision was taken to fortify Britain's naval dockyards to protect them from landward attack. However, construction of defences for Chatham Dockyard did not commence until January 1756, just before the outbreak of full-scale war with the French in May that year. An engineer officer, Lt Hugh Debbieg, was tasked with implementing the plan designed by a Board of Ordnance architect, Col John Desmaretz, just the previous year. The fortifications comprised of various bastions, ditches, ramparts, tunnels and barracks. These works became collectively known first as the Cumberland Lines and later as the Chatham Lines. A new Chatham Barracks was also built to house the garrison that manned the Lines.

In the 1770s, the Lines were improved by revetting the ditches with brick and by the addition of sally-ports. At the same time, they were also extended to reach Chatham Gun Wharf on the River Medway to the south. Between 1779 and 1782 two self-contained redoubts, Townsend and Amherst redoubts, were built at either end of the Lines.

The Lower Lines was the last section of the Chatham Lines to be constructed. The works were started in 1803 in advance of the Napoleonic Wars. It extended the earlier section in the south-west as far as St Mary's Creek and, effectively, the River Medway to the north.

These early years of the nineteenth century saw yet more improvements and additions particularly around the Amherst Redoubt, including a new guardhouse and barracks and the excavation of a tunnel system to connect the redoubt with the lower gun batteries. A new Military Road was also built, which connected the Lines to the outlying Fort Pitt. A new barracks was built at Brompton, designed by James Wyatt and described as 'one of the largest and most impressive examples of military architecture in the country, having a compositional system ... of Palladian monumentality'. The north, south and west blocks were built between 1804 and 1806 as an artillery barracks, the largest built by the Ordnance Board during the Napoleonic Wars. It originally housed 1,300 troops in dormitories with stables and gun-carriage sheds nearby. Wyatt arranged the three blocks to frame a huge quadrangle, which provided a splendid backdrop for military parades. In 1812 the barracks became the home of the Royal Engineers when the School of Military Engineering was established there. By 1824 the Royal Engineers had taken over the whole barracks as the artillery garrison moved out.

Improvements continued to be made to the Lines over the ensuing years but by the 1820s, as the range and power of artillery improved, the defences were already considered obsolete. Around this time the Outer Lines, a large open area originally designed to maintain a clear field of fire in front of the ramparts, began to be used for horse racing; the Chatham Races in August were to become a regular fixture in the horse racing calendar for several years – they eventually ceased when the lawlessness among the crowds stretched the resources of the local police to the limit.

The Lines were still being used for training purposes, particularly by the Royal Engineers, who practised their siege and bridging techniques here. These siege exercises became a regular summer spectacle at Chatham, continuing into the 1890s and attracting thousands of spectators.

Right: The Barrier Ditch at Fort Amherst extending to the Gun Wharf.

Below: The Lower Lines at Gillingham.

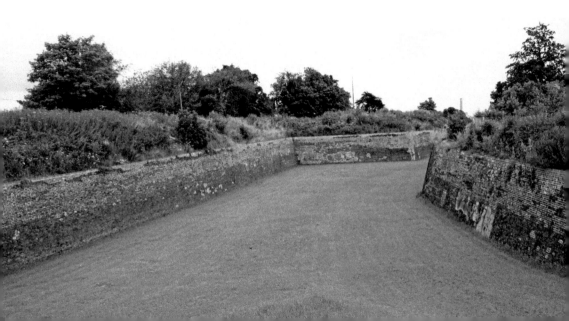

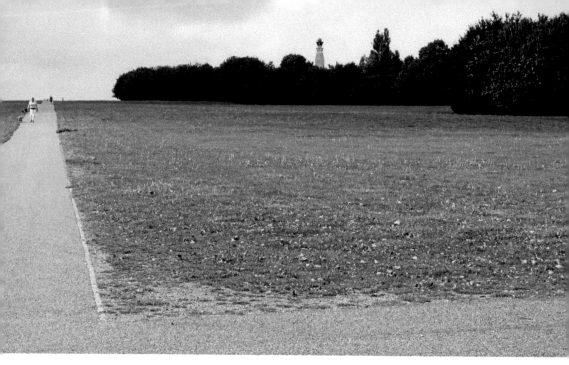

The Outer Lines, now the Great Lines Heritage Park.

The defence review of 1860 declared the Lines redundant and by 1871 the northern extremities of the Lines were demolished to make way for the extension of Chatham Dockyard. Part of the Inner Lines in Brompton were turned into parkland for the recreation of officers and their families.

In the First World War, the Outer Lines was used as a training camp, designated No. 1 Training Depot. During the war, tens of thousands of recruits were trained here, the vast majority billeted in tented accommodation, which must have been very uncomfortable in the winter months. The end of the war saw a great reduction in military activity on the Lines. In 1923 a Royal Navy war memorial was built on the Outer Lines as a tribute to those sailors lost at sea during the war, and around 1926 the first Army housing was built on the Inner Lines near the demolished sally-port.

In 1938 construction began on an underground complex beneath the Lower Lines at Gillingham to house the headquarters of the Royal Navy's Nore Command. Additional space was also allocated to the Army and RAF, and in the Second World War the complex became a joint headquarters, designated Area Combined Headquarters (ACHQ) Chatham. When the Nore Command was disbanded in 1962 the ACHQ was closed. Internal alterations were made to the complex over the following two years and mains water and drainage laid on. The site was recommissioned in 1966 as the headquarters of the Royal Naval Reserve, Chatham, and named HMS *Wildfire*. The complex continued operating even after the Navy's withdrawal from Chatham, but was eventually decommissioned and sealed up in the late 1980s.

The Army vacated Kitchener Barracks (the original eighteenth-century Chatham Barracks) in 2010 and the site is now awaiting redevelopment, leaving just the Royal Engineers School of Military Engineering at Brompton Barracks as the only remaining military presence in the Chatham area.

Of the 1 ¾ miles of the 'Lines' built, almost 1 ½ miles remain, with most of them now publicly accessible and well worth a wander around. Guided tours of the tunnel system at Fort Amherst are also available for a small charge. Check their website for details. The Royal Engineers' former Electrical School on Prince Arthur Road is now their library and museum and also makes a very interesting visit.

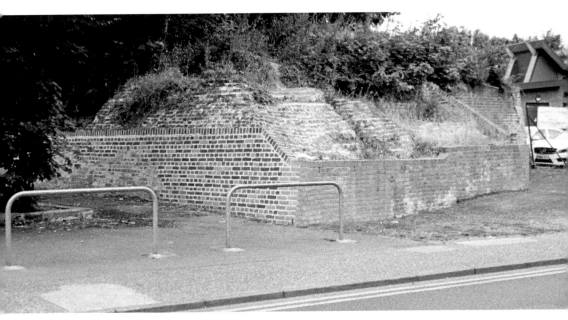

Above: The remains of the Sally-port on the Inner Lines at Brompton.

Below: The sealed-up emergency exit for HMS *Wildfire*.

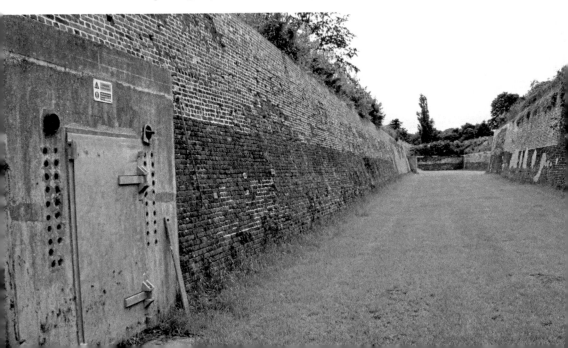

Chapter 4

Sheerness Dockyard

With the outbreak of war with the Dutch in 1665, the Admiralty Board quickly realised that they had a major problem with the three principal Royal Dockyards being sited far upriver from the sea; Chatham on the Medway and Woolwich and Deptford on the Thames. It would take days for the Navy's larger ships to negotiate the narrow passage of the shallower waters near the dockyards and so it was decided that a facility closer to the open sea was required to store, maintain and repair these ships.

The broad mudflats at Sheerness, which were exposed at low tide, were already being used by the Navy to clean and effect minor repairs to those parts of ships' hulls that were normally submerged, and so the area was soon under consideration as the site for a new dockyard.

In August 1665 a small party of senior officials from the Navy Board, including Samuel Pepys, landed at Sheerness to survey the ground and mark out the layout of the proposed new yard. Construction work commenced shortly after and by mid-November it was already considered suitable for the refitting of the Navy's larger ships. Meanwhile, construction also began on a new fort to protect the dockyard on a site adjacent to it. Unfortunately, work on the fort was very slow and was still not complete when the Dutch fleet mounted a major raid on the Medway in June 1667. The few defenders at the incomplete fort soon gave up their struggle in the face of the superior firepower of the Dutch ships. The Dutch then landed troops, destroyed the fort and temporarily occupied the dockyard. By 1674 the conflict with the Dutch was over and construction work on the dockyard was completed.

Most of the yard's manual workers and their families lived on hulks which had been sunk onto the nearby muddy foreshore. The conditions in the hulks were very unsanitary and malaria and other diseases prospered. The workers began to move onto the land outside the dockyard walls and built shacks made from the single planks of timber they were allowed to remove from the yard each day. Most of these planks had already been painted in dark grey-blue dockyard paint and the shacks were soon nick-named 'Blew Houses' and, as the community grew during the eighteenth century, the area became known as Blue Town.

In 1813 work commenced on a complete rebuilding of the dockyard. A new Great Basin, dry docks, building slips, storehouses and other associated buildings were constructed, and the work was completed in 1823. The yard was now fully equipped for

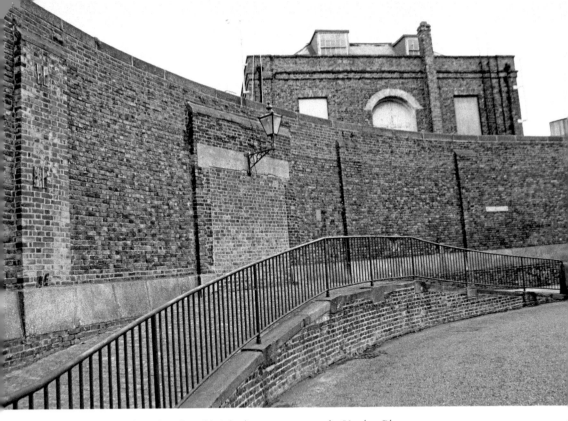

Above: The Dockyard wall and bricked-up entrance to the Yard at Bluetown.

Below: The Captain-Superintendent House, home of the Yard's senior officer, built around 1827.

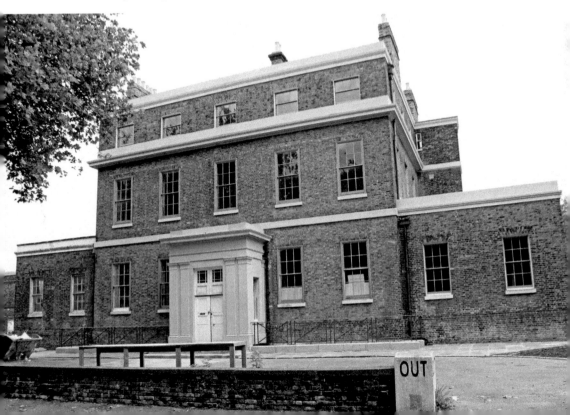

the building and repairing of the Navy's largest oak-built, broadside-firing sailing ships, but within just a few years these great 'Ships of the Line of Battle', whose class had seen such glory at Trafalgar, were already becoming obsolete.

The Navy's first steam-powered vessel had already been launched at Deptford in 1822 and as the Industrial Revolution progressed, so the yard found itself having to adapt very quickly to new technologies. As well as the advent of steam-power, paddles were replaced by screw propellers and wood construction gave way to iron and eventually to steel. Many of the traditional dockyard buildings had to be adapted for these new engineering technologies and were converted into machine and fitting shops, a process that continued throughout the rest of the nineteenth century. In 1828, a dockyard church to cater for the religious needs of the yard's rapidly expanding workforce was built and in 1830 the new accommodation for the principal officers of the dockyard was completed.

A new gunnery school was established at the dockyard in 1892, housed in one of the 1820s storehouses that had been in use as a barracks since the 1850s. New drill sheds and gun sheds were also erected but the school soon outgrew its premises – it closed in 1908 and moved to the new naval barracks at Chatham. Meanwhile, having launched its last ship (the sloop *Cadmus* in 1903) the yard was switched to a primary role of refitting torpedo boats and torpedo boat destroyers.

In the First World War, the dockyard worked at full capacity, repairing and maintaining vessels. Security at the yard was increased, with the dockyard police being issued with sidearms. In 1916, invasion fears led to the whole Isle of Sheppey being declared a restricted military area and its defences were strengthened, particularly those in the vicinity of the dockyard. However, these defences remained untested until the end of the war in 1918.

Following the Armistice, the workload of the dockyard rapidly declined and many workers were laid off. In the 1920s, in order to keep the yard working, some vessels that were being built in private yards were ordered to Sheerness for 'fitting-out' and completion. Despite this new work, the Admiralty announced the yard's closure in 1928, but the government overturned the closure on political grounds. In hindsight, it proved to be a wise decision.

With the rise of Nazi Germany in the 1930s and the consequent naval rearming, work at the yard gradually increased and by September 1939 the workforce was almost back up to full strength. During the Second World War, the dockyard became a minesweeper base and was one of the main assembly points for vessels embarking on the Dunkirk evacuations.

After the end of the war, the dockyard once more fell into decline and in February 1958 the government announced that it would be closed. On 31 March 1960 a closing ceremony took place and the Royal Navy departed.

The yard is now a thriving commercial port, handling cargoes from around the world. Despite extensive redevelopment, several interesting dockyard buildings survive within its boundaries, including the Boat Store, which is now the earliest surviving example of multistorey, iron-frame and panel structure and the forerunner of all modern-day skyscrapers.

Unfortunately, as they are sited in a secure area, opportunities for the public to view these buildings are rare. However, the remains of the Dockyard Church and the renovated Naval Terrace can be seen as they lie outside the port's secure perimeter.

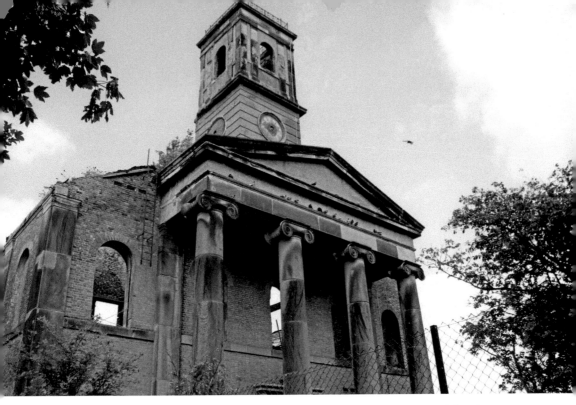

Above: The remains of the Dockyard Church, which are now in the care of the Sheerness Dockyard Preservation Trust.

Below: Officers' Terrace. These houses, along with those of Naval Terrace, provided homes for the Yard's principal officers.

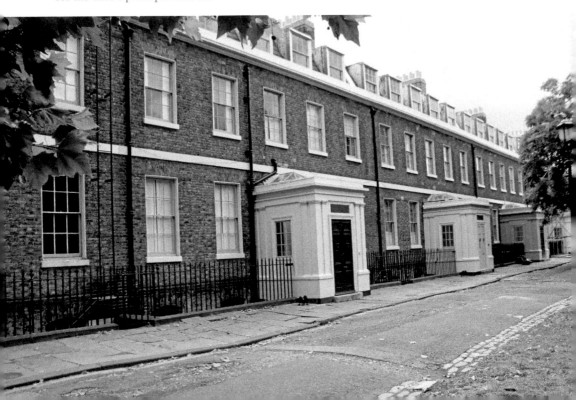

The Boat Store.

Chapter 5

Martello Towers

To counter the threat of invasion from Napoleonic France, a number of small forts were constructed along Britain's coastline between 1803 and 1808. Their design was based on a sixteenth-century, round defensive fort at Mortella Point in Corsica that had successfully managed to fend off attacks from British warships for two days in 1794. It was only captured when troops were landed and field artillery used to bombard its walls.

A typical British version would be about forty feet tall with two floors and have a diameter of around 45 feet. The Kent towers were elliptical in plan and resembled an upturned plant pot. The walls were 8 feet thick. The only entrance would be sited 10 to 20 feet off the ground and could be reached by a retractable ladder, which was overlooked by loopholes in the walls through which muskets could be fired, making any access extremely difficult and dangerous for attacking infantry. Some of the towers were moated as an additional defensive measure. The flat parapet roof mounted a raised, traversing gun platform supported by a central pillar, which ran up from the base of the tower. This arrangement gave the single heavy gun a 360-degree arc of fire over the parapet walls.

Inside the towers, the garrison of one officer and twenty-four men would be accommodated on the first floor while the ground floor was used as a magazine and storeroom. Water supply usually came from either a well or a cistern in the basement and rainwater was collected from drains in the roof through internal pipework connected to the cistern tank. Most of the towers were situated on or near possible invasion beaches. They were sited roughly 600 yards apart from each other and mounted a 24-pounder long-range cannon.

Developments in naval gunnery eventually rendered the towers obsolete and many were taken over by the coastguard, who used them in their operations against smuggling.

Of the seventy-four Martellos built around the south-east coast of England, twenty-seven were located in Kent and were sited on the stretch of coast between Folkestone and St Mary's Bay. They were all individually numbered with Martello No. 1 built on the Warren at Folkestone and No. 27 at St Mary's Bay. The Martello design can also be seen incorporated into other Kent fortifications, including the Grain Tower Battery at the mouth of the River Medway, Dymchurch Redoubt, Sandgate Castle and the Centre Bastion at Sheerness.

Of these twenty-seven Kent towers, sixteen remain, the others having either been demolished or lost to the sea. Most of the remaining towers are now in private ownership; some have been converted into luxury homes or holiday lets but others have been left unused and in poor condition. Some examples of the Kent towers follow.

Martello No. 1 stands high up on the cliffs above East Wear at Folkestone. As early as 1870 it had already lost its outer skin of brickwork. It was bought by the Folkestone Corporation in the 1970s, who undertook essential repair work. In the 1990s the deteriorating cement rendering was replaced with brick, a ground-floor door was added and new windows installed on both floors. The tower has continued to undergo renovations for many years with the aim of turning it into a private residence.

Martello No. 3 at Copt Point, Folkestone, was used in Second World War as an observation post and minefield control tower. After the war it remained disused until 1990, when Shepway Council opened it as a visitors' centre. It was later used as a temporary lookout for the National Coastwatch Institution until 2002, when they moved into a nearby Second World War artillery battery observation post that had been converted for their use. Since then, the tower has remained disused and unfortunately prone to graffiti vandalism. Although, like most of the other remaining towers, it is a Scheduled Ancient Monument, its future use is uncertain.

Martello No. 9 is a moated tower situated on the south side of Shorncliffe Camp at Sandgate. Being sited on military land, it has remained in its original form. Almost all the stucco rendering remains fairly intact and most of the brickwork in the ditch is in good condition. The site is now open access so the door has been bricked up to deter vandals. Unfortunately, the tower is now beginning to display some signs of neglect and the site is becoming overgrown. Its future is uncertain and English Heritage have placed it on their Buildings at Risk Register.

Martello No. 1 undergoing renovation in 2013.

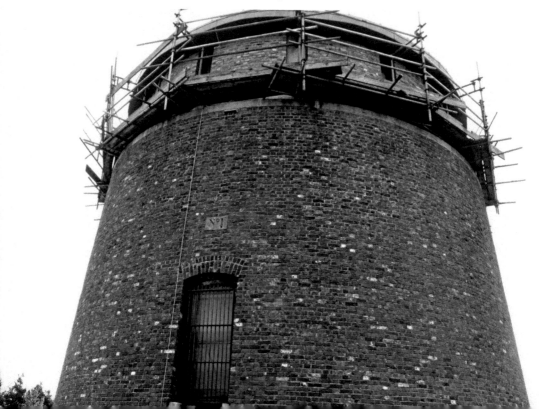

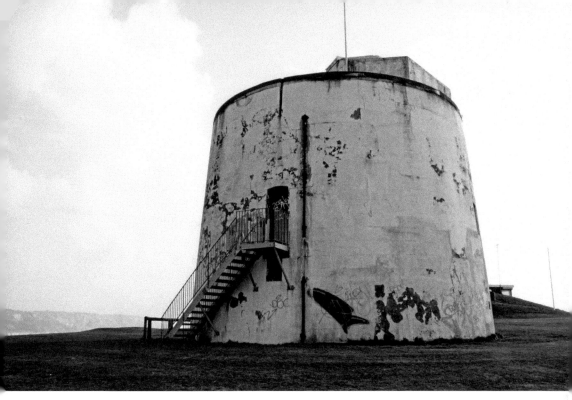

Above: Martello No. 3 with the Second World War observation post on its roof.

Below: Martello No. 9 displaying signs of its deteriorating condition.

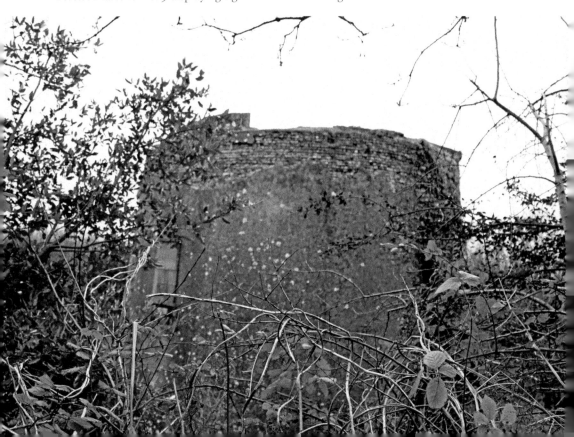

Martello No. 13 on Western Parade, Hythe seafront, was sold to a builder in 1928, who undertook repairs and renovations and converted it into a residence. It was sold again in 1938 and used as an observation post in the Second World War. Further renovations and modernisations were carried out in the 1960s – new large windows were added and the walls were made thinner by the removal of the internal layer of brickwork in order to increase the floor space. At the same time, a new room was added to the roof. The tower has remained as a private residence ever since.

Martello No. 24, just off Dymchurch High Street, was used by the coastguard up until the 1950s. It was taken over by the Ministry of Works in 1959, who proceeded with its restoration. It was first opened as a museum in 1969 and is now owned and managed by English Heritage as the only museum solely dedicated to the history of all the Martello Towers. It has been fully restored to its original design and has been re-equipped with its original cannon. Internal public viewing can be arranged by appointment.

Martello No. 13 converted into a residence.

Martello No. 24 photographed in 2015.

Chapter 6

The Drop Redoubt – Dover Western Heights

The Drop Redoubt is an artillery fort forming a major part of Dover's Western Heights fortifications. Occupying much of the eastern edge of the fortress, it dominated the town and port below. It was initially planned as an irregular quadrangular fort, surrounded by a deep ditch and it was designed to be mostly self-contained, with its own barracks, guns and magazines, but was linked to other parts of the fortress via connecting ditches and parapets. The fort takes its name from the remains of a Roman pharos or lighthouse (the twin of the more complete example at Dover Castle) that is sited within its walls. These remains were known by locals as the 'Devil's Drop of Mortar'.

The irregular pentagonal shape of the fort is clearly displayed in this aerial photo from 2015.

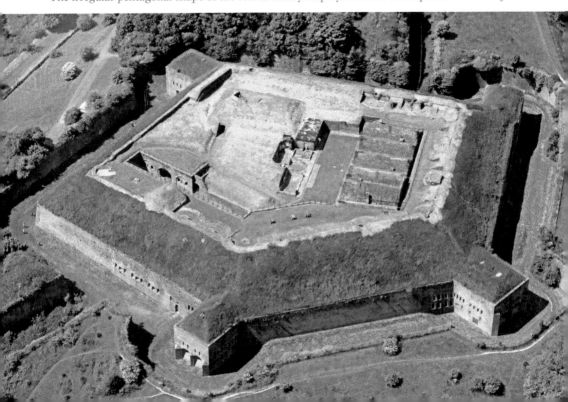

Construction commenced in the 1780s under the charge of the engineer officer, Lieutenant Thomas Hyde Page, but the major building phase took place during the 1804 to 1816 war with France under a revised plan put forward by the chief royal engineer in Dover, Captain William Ford. This revised plan included the deepening of the ditches and a change to the north-east, where two faces replaced one, thus giving the fort an irregular pentagonal shape.

On completion the fort was armed with fourteen heavy guns and nine mortars. The four bombproof casemated barracks could accommodate 200 men with the officers being housed in their own quarters on the other side of the fort.

In 1823, a new entrance was constructed on the south side of the fort. It was reached by way of a swing bridge across the ditch from the counterscarp. Two-thirds of the bridge consisted of a fixed-span section from the counterscarp supported by brick piers, the bases of which are still visible in the ditch today. The movable section made up the remaining third of the bridge. It swung on a fixed pivot mounted in front of the new entrance. To deny access to the fort to any enemy, the movable section would be rotated back to lodge flush against the fort's curtain wall.

By 1830, the fort's importance had diminished and the garrison had been reduced to just eighty-four men under the command of a captain. However, by the mid-nineteenth century concerns re-emerged over French military ambitions, which resulted in further improvements and modernisations of the fort being made between 1858 and 1867. These included the addition of large two-storey caponiers on four of the corners of the fort; these would serve as gun rooms to provide flanking fire along the ditches. These caponiers and their gun rooms housed fifteen 12-pounder carronades.

The terreplein was remodelled to accommodate eleven modern 7-inch rifled breech-loading (RBL) guns, which covered the land front to the north of the fort. The men's barracks accommodation was improved to comply with the requirements of the 1858 report of the Hospitals and Barracks Committee and new officers and sergeants' quarters were built. Other improvements included the bombproofing of the main magazine and the building of a new guardhouse and ablutions block.

The fort's armament was upgraded in 1892 with the installation of six 64-pounder rifled muzzle-loading (RML) guns and the addition of two machine-guns mounted on parapets. The 12-pounder carronades in the caponiers were replaced with six heavier 24-pounder weapons. By 1902, however, the decline in the Drop Redoubt's importance as an artillery fort meant that only the two machine guns remained and by 1910 these too had been removed, thus reducing the fort to barracks status.

At the outbreak of the First World War, the mayor of Dover formed a volunteer organisation of local men to assist the armed forces based in the town. It was decided that they could be best used to man the new searchlight batteries that were being installed to help defend the harbour from air attacks. Responsibility for organising and running the volunteer group was taken over by the Admiralty and they became part of the Royal Naval Volunteer Reserve (RNVR) and were known as the Dover Anti-Aircraft Corps. The Corps was divided into three companies with No.1 Company with its lights being stationed at the Drop Redoubt. Two QF 6-pounder guns were also installed at the fort for use in the anti-aircraft role. The Corps was disbanded in 1916 when the Army took over responsibility for anti-aircraft defence. The AA guns were withdrawn in 1917 and after the end of the war the Redoubt was further reduced to a regime of care and maintenance only.

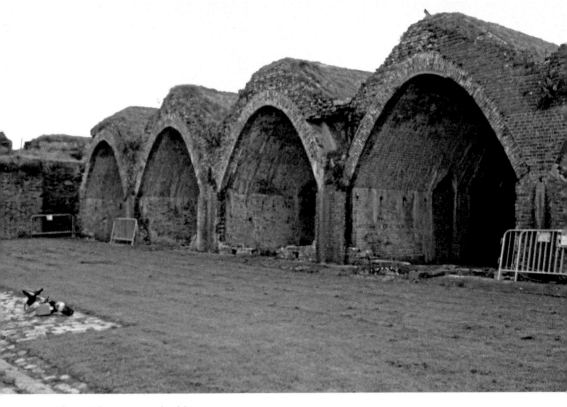

Above: The casemated soldiers' quarters.

Below: The main entrance to the fort, which was made redundant when the swing bridge was demolished.

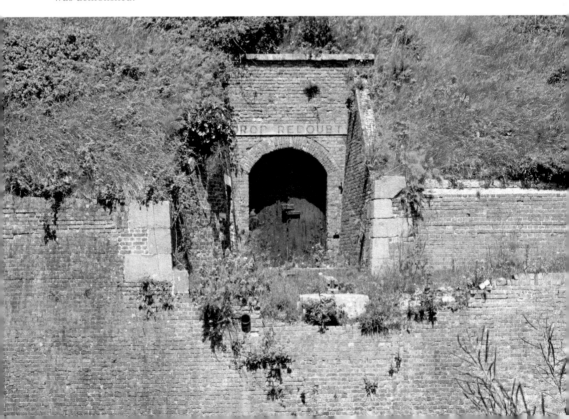

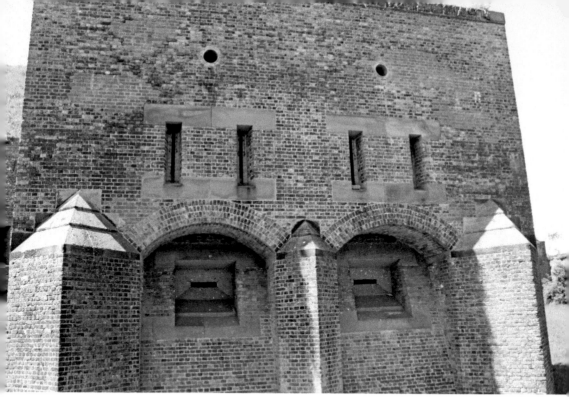

Above: One of the caponiers added to the fort around 1860.

Below: The officers' quarters.

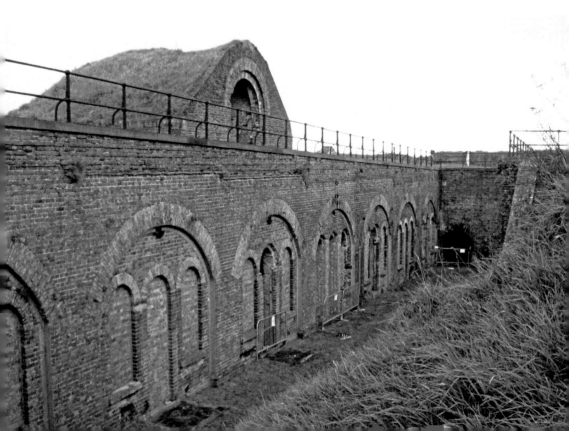

In the Second World War a commando unit, 4 Commando under the command of Lord Lovat, was based at the fort. They trained here for a raid on Boulogne in April 1942 codenamed 'Operation Abercrombie'. An observation post was constructed on top of the main magazine mound, which was manned by members of the Royal Observer Corps who were able to monitor approaching German aircraft as well as identifying the muzzle-flashes of their long-range coastal guns across the Channel.

The end of the war saw military activity soon decline at the fort. The Army finally withdrew altogether in the mid-1950s and the fort soon fell into neglect. Trees and other vegetation rapidly colonised the ditches and terreplein and the condition of the structure deteriorated. The site is now owned by English Heritage and the Western Heights Preservation Society and its enthusiastic members hold regular workdays clearing vegetation and carrying out repairs, allowing them to host popular 'Open Weekends' twice a year so the public can safely view inside the fort. The ditches surrounding the fort are publicly accessible all year round.

Chapter 7

Fort Horsted – Chatham

Fort Horsted was the largest of Chatham's four 'outer-ring' forts built to defend the dockyard from landward attack from the east (the others being Forts Luton, Borstal and Bridgewoods). It is situated on a site three miles from the Dockyard which was deemed most suitable as being beyond the maximum range that bombarding artillery could reach at that time.

Fort Horsted was connected to the other 'outer-ring' forts by a light railway. The railway initially served to assist with supplying materials for the construction of the forts. Building materials were brought by barge up the River Medway to a quay at Borstal where they were unloaded and then hauled up the slope of the North Downs by a steam-powered ropeway to Fort Borstal. Here they were loaded into wagons and distributed around the various building sites using the railway. It was later planned to extend the line to Chatham Dockyard so it could be used to transport supplies to the forts by rail in times of siege. However, nothing came of these plans and the line soon fell into disuse. During the First World War the tracks were eventually taken up.

Work commenced on Fort Horsted in 1880, using convict labour from the nearby Borstal Prison and supervised by Royal Engineers. It was designed in the shape of a six-sided arrow head with extensive ditches, magazines and tunnels. Initial work concentrated on building the main central tunnel and its two connecting rows of casemates.

The tunnel was formed using timber formers on which bricks were laid and then covered with several feet of concrete. In March 1889 a tragedy occurred when thousands of tons of earth and rubble suddenly gave way as six convict labourers were excavating one of the tunnels that led to the interior of the fort. They had dug out the tunnel to a length of 20 feet when they noticed movement in the earth above them, followed by a large fall of rubble. Three of the six convicts managed to make their way safely back to the tunnel entrance but, just 10 feet from the entrance, one man fell over a barrow as another huge fall of earth crashed down, burying him under the barrow. The remaining two men managed to scramble over the fallen pile of rubble and squeezed through the small gap left between the pile and the tunnel roof. The dead body of the buried convict was eventually recovered by civilian labourers.

The fort was designed to accommodate a garrison of 400 men and house a large variety of artillery. There were no 'fixed' gun installations, instead it would have received mobile artillery of various types and calibres as and when required. The guns would have

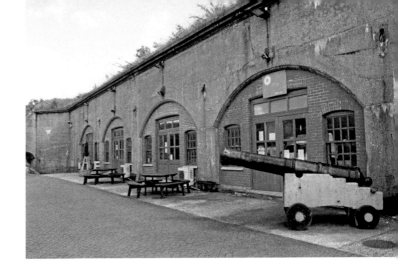

The Right Gorge Casemates, now converted into small business units.

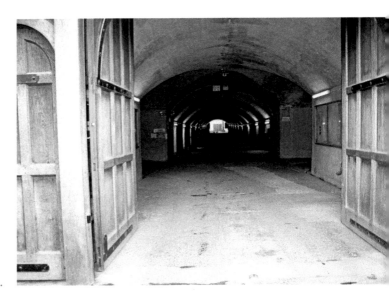

The main entrance tunnel.

been supplied with ammunition from ten expense magazines located on lower levels around the fort. These magazines were all equipped with hoists to bring the munitions up to the gun serving rooms directly above.

The fort was surrounded by dry ditches, which were defended by three counterscarp galleries accessed by stairs and tunnels from within the fort. The galleries were provided with rifle loops and gun ports, enabling the ditches to be swept by fire in the event of an attack.

The main entrance was at the rear of the fort via a drawbridge across the ditch. The entrance and ditch were defended by flanking galleries from which fire could be directed along them. The fort was also provided with two large internal reservoirs which served as header tanks to supply water, via pipes, to the neighbouring Fort Luton and Fort Bridgewoods.

By the time construction had been completed in 1889, the improvements in the range and velocity of artillery had already rendered the fort obsolete and it spent most of its military life as a magazine and storage depot. However, as late as 1907 its defences were put to the test when a siege exercise involving the 'outer ring' forts was undertaken.

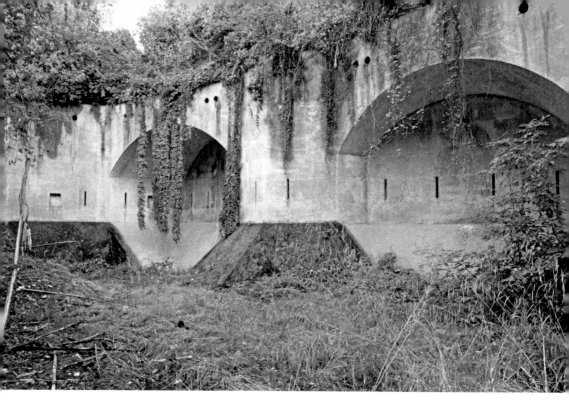

Above: One of the Counterscarp Galleries viewed from the ditch.

Below: The main entrance and bridge.

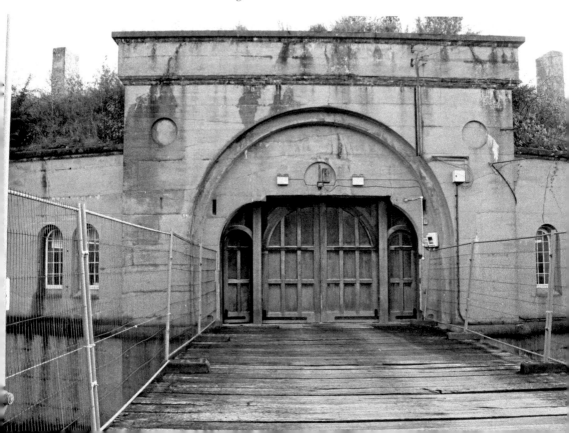

The exercise took the form of a mock 'assault' by 2,500 men on Chatham dockyard. The assault gave particular attention on mining techniques to breech the fort's outer defences and the counter-mining operations to thwart them. Although the exercise focused on Fort Luton and Fort Bridgewoods, both of which 'fell' within a month, important lessons were learnt that applied to Fort Horsted as well. Even though far from impregnable, it proved the forts could still severely delay an attacking force if required to do so.

Fort Horsted remained in military hands until the 1960s and housed army units in both world wars. During the Second World War the fort was armed with anti-aircraft guns, which claimed a number of 'shoot-downs' during the Battle of Britain.

The War Department sold the fort in 1961 to a private development company, who, in turn, sold it on to to a tyre company in 1970. The tyre company used the ditches and tunnels to store thousands of scrap tyres and, almost inevitably, in 1976 the fort suffered a large fire. The fire caused some superficial damage, some evidence of which can still be seen today.

By the early 1990s, the fort had fallen into a sad state of neglect with many of the units in need of repair and vegetation growing unchecked over much of the site. In 1997 it was put up for auction. The new owners set out a plan to clear the site and restore the buildings for use as small business units. The fort is now a thriving small business centre with modern conference facilities and reception area. It has also been used as a television and film location and regular guided history tours are held, usually led by a knowledgeable local historian.

One of the Second World War anti-aircraft gun emplacements.

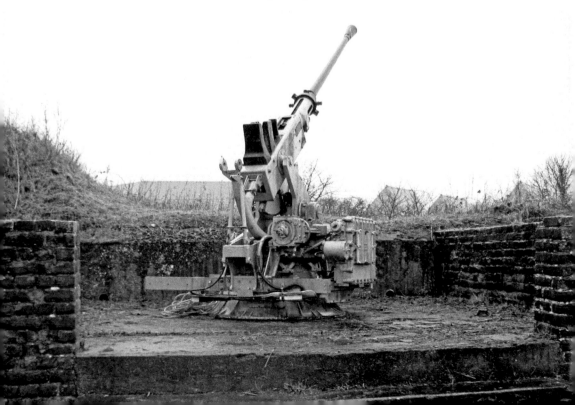

Chapter 8

Slough Fort – Allhallows

Slough Fort in Allhallows, Grain, was built in 1867. It was one of the smallest forts proposed by the 1860 royal commission on the defence of the United Kingdom. It was also the first of the proposed forts to be completed. Its purpose was to oppose any enemy troops landing on the flats in this part of the Thames Estuary and advancing overland towards Chatham dockyard. The site for the fort was chosen because it was the only accessible point for an enemy to land in order to make an attack on the dockyard from the north. Advances from all other possible landing sites in the area could be prevented by flooding the surrounding marshlands.

The fort originally consisted of seven granite-faced casemates and mounted seven 7-inch, 7-ton rifled breech-loading guns (RBLs). Accommodation was provided for three officers, one NCO and seventy men. The total cost of construction on its completion in 1867 was £27,343 against an initial estimate when the work was first scheduled in 1862 of £15,000.

Despite the construction being completed on schedule, the fort did not mount its main armament until January 1872, when a detachment of fifty NCOs and men of the Royal Artillery arrived from Sheerness ready to prepare for the task. On 10 February the seven 7-inch guns were shipped from Woolwich to Chatham Gun Wharf, where they were unloaded and then towed to the fort by two traction engines.

However, its construction meant the fort was more danger to itself than to any enemy. The granite D-shaped building sprouting up from the bleak landscape was easily visible to enemy shipping and its 7-inch guns lacked the range to engage them out in the deeper channels of the estuary.

The fort was greatly improved in 1891 with the addition of earthworks to hide its stark profile and again in 1895 with the construction of two 'wing' gun batteries. The left-wing battery mounted two 9.2-inch breech-loading guns and the right-wing battery two 6-inch breech loaders. These guns were all mounted on hydro-pneumatic disappearing carriages in hidden pits, making them very difficult targets to hit. They worked by rising out of their pits into position to fire and their recoil forced them back down out of sight. Later, the introduction of smokeless propellants removed most of the giveaway signs of fire, thus further reducing their visibility to any enemy.

In 1906 the two guns in the right-wing battery were replaced with two 9.2-inch breech-loading guns on barbette mountings that allowed them to recoil along their

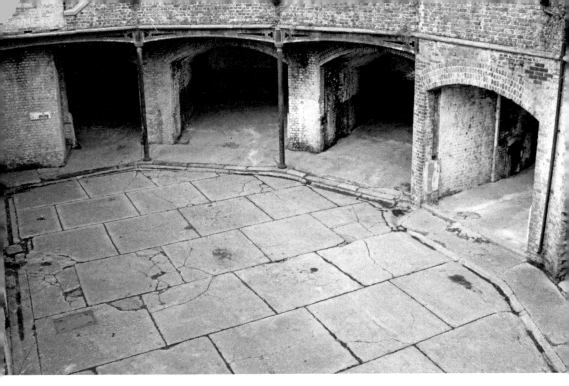

Above: The Casemates.

Below: The Left Wing Battery.

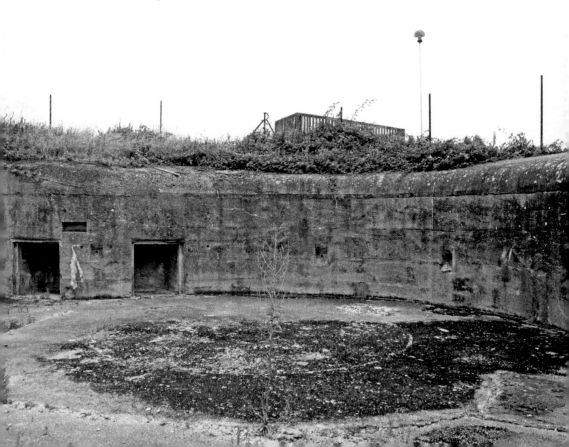

axis, thus delivering a faster rate of fire. To accommodate the new guns, the battery was almost completely rebuilt, with new concrete aprons and the emplacements realigned. At the same time the left-wing battery was abandoned.

In the First World War the fort was used as a port war signal station to control shipping access to the Thames. It still retained its heavy armaments until 1917, when the two remaining 9.2-inch guns were removed.

The Army continued to occupy the fort until 1920 and the War Office eventually sold the site in 1929. The new owners planned to develop the surrounding land to create a leisure and holiday resort with a small zoo. By the mid-1930s various new facilities, including a rail link to Allhallows, had become established to serve the thriving new resort.

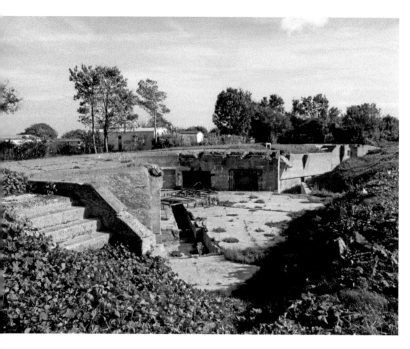

The Right Wing Battery.

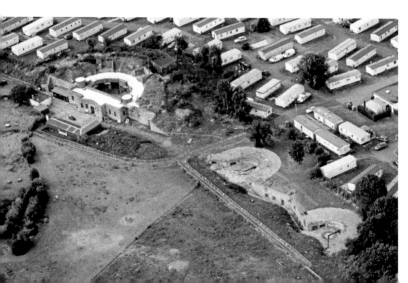

The fort and surrounding holiday park seen from the air in 2016.

By 1938 the shadows of war were once again appearing over Europe and the fort became home to an Observer Corps post. The Observer Corps were a civil defence organisation staffed mostly by part-time volunteers. They were responsible for the visual detection, identification and tracking of enemy aircraft once they had entered UK airspace.

With the outbreak of the Second World War, the military once again took over the fort and two 4-inch guns were mounted on its roof. It also became the administrative centre for a number of local anti-aircraft gun batteries and later in the war the fort itself mounted some AA guns, which were used in the defence against the German V-1 rocket attacks.

In the late 1950s, the leisure park, including the fort, was taken over by the local council and they soon considered the fort to be a dangerous structure and recommended its demolition, but the costs for this proved to be prohibitive.

The site once more passed into private ownership and the integrity of the fort began to be threatened as the ditches were filled in and the ramparts flattened to allow for the placement of more caravans. In the mid-1960s, the fort began to be used as riding stables, an activity that continues here to the present day.

The fort's current owners, Bourne Leisure, have big plans to restore it and turn it into a major visitor attraction for its Allhallows Leisure Park, and they are ably assisted by a dedicated team of volunteers who hold regular monthly workdays throughout the year. Although not generally open to the public, the fort does hold occasional open days when you can join conducted tours, be shown around the site and learn more about its history from the very knowledgeable guides and the various displays on show.

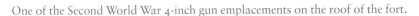

One of the Second World War 4-inch gun emplacements on the roof of the fort.

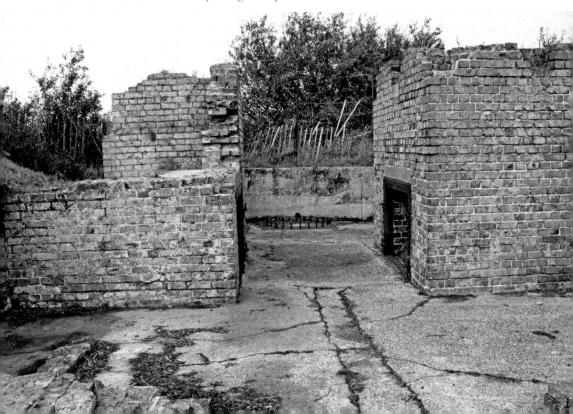

Chapter 9

Garrison Point Fort – Sheerness

The extensive rebuilding and expansion of Sheerness dockyard in the 1820s involved the demolition and levelling of much of the yard's defences, in particular the western and southern ends of Sheerness Fort, which had stood there since 1668. Regardless of the construction of new defences further inland, concerns were soon raised regarding the vulnerability of the town of Sheerness as well as the dockyard to attack.

Despite these serious concerns, it was thirty-five years before the situation was remedied. As a result of the report from the 1860 Royal Commission on the Defence of the United Kingdom the decision was taken to build a new two-tiered casemated fort at Garrison Point, Sheerness. The fort was constructed from granite with iron shields to protect its guns. Construction began in 1861 and was completed in 1869 at a cost of £150,979. It was semicircular in design with two tiers of seventeen casemates and underground magazines. Progress on the early phases of the forts construction were reported in *The Times* of Thursday 28 May 1863:

> The foundations of the massive casemated fort to be placed at the extreme limit of Garrison Point have been laid upwards of twelve months, since which operations have been entirely suspended in order to allow the foundations to solidify and become settled before the battery is erected. The substructure having had sufficient time to settle, the first section of the superstructure will be proceeded with the portion of the fort embracing the main tier of casemates, which are intended to mount guns of the very heaviest metal. The form of the fort is semi-circular, with its front facing the main channel approach to Chatham harbour. It will consist of two storeys or tiers, and will be constructed of a strength far surpassing any modern structure of that kind, so as to be able to mount the heaviest known kind of ordnance.

On completion the fort was armed with thirty-six 9-inch RML guns housed on its two gun floors. In 1884 a Brennan torpedo station was constructed at the fort. The Brennan was one of the world's first guided weapons. It was controlled with wires by its operators from directing stations and housed in telescopic steel turrets, which could be raised to a height of 40 feet. The operators were equipped with special binoculars on which were mounted electronic controls to steer the torpedoes towards their target. The fort was equipped with three torpedo launch ramps, each with its own control turret. In 1907,

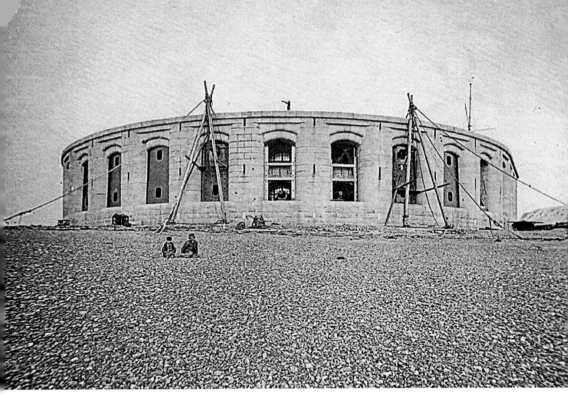

Above: The fort under construction in the 1860s.

Below: Aerial view of the fort in 2014.

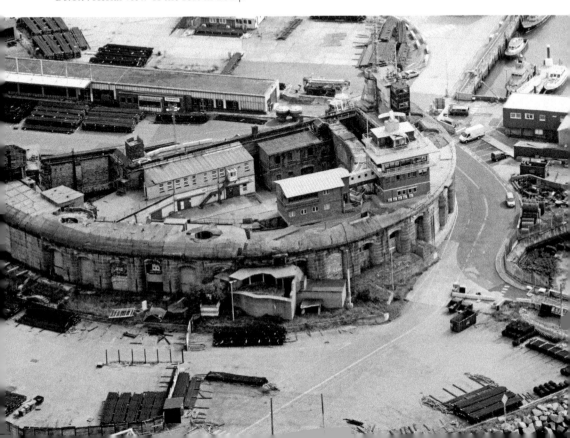

due to its short range (just 2,000 yards), the Brennan system was deemed obsolete and was removed from the fort, but some of its infrastructure remained in place, including the directing station turrets, which were later converted into machine-gun posts.

Local volunteer units used the fort for their weekend and summer camps. The Kent Artillery Volunteers had been the first group to use the fort for a few days a year. In 1888, their fifteenth year using the fort, they were led by Colonel Hughes MP. They had travelled from their depot in Woolwich by train to Port Victoria and from there by the steamer *Cupid* to Sheerness Pier. From there, they paraded through the town, led by the band and watched by cheering crowds. On their arrival at the fort they were stationed in the upper and lower casemates. While at the fort, they practised on the 64-pounder RML guns and the 40-pounder BL guns, firing them at targets out to sea. When off-duty at Sheerness, the volunteers were more than happy to partake in the pleasures offered by the notorious pubs and 'flesh pots' of Blue Town!

The fort's armaments were remodelled several times to keep up with the changes in artillery practices and technology. In the early twentieth century, the fort became an anchor point for a boom defence across the entrance of the Medway. The boom extended to its other fixing point at Grain Tower, denying access to the river by enemy shipping in times of war. By the outbreak of the First World War, most of the gun casemates had been converted into stores and accommodation and the armament reduced to two rifled breech-loading (RBL) 6-inch guns and two 12-pounder quick-firing (QF) guns, all of which were mounted on the roof of the fort.

In the Second World War, two new gun emplacements were added to house 6-inch RBL guns and two new twin 6-pounder gun towers were built to combat marauding German E-boats.

The Casemates.

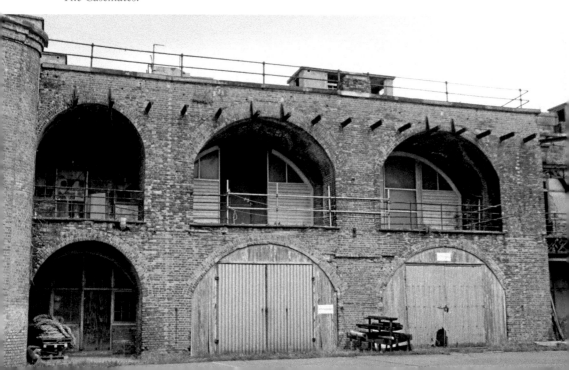

The fort remained in service until 1956, when the coastal artillery units were disbanded. With the closure of the royal dockyard in 1960 the whole site, including the fort, was transferred to the Medway Ports Authority. In 1963 the Royal Naval Auxiliary Service (RNXS) was established. This was a uniformed civilian volunteer service which could be used to support the Royal Navy in time of war by assisting with the evacuation of ports and the shepherding of merchant vessels safely out to sea in case of attacks on the UK. The Sheerness detachment of the RNXS was housed in a bunker under Garrison Point Fort, which had been converted from the Victorian magazines and tunnels. They were provisioned with enough supplies to last for a month. The RNXS was disbanded in 1994 and the bunker at the fort was abandoned.

The fort survives in very good condition with most of its features intact and remains in use today as an integral part of the port of Sheerness. Unfortunately, it lies within the port's security zone and is therefore not accessible to the general public.

One of the Second World War twin 6-inch gun towers.

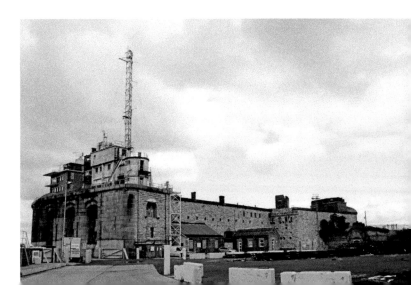

The fort viewed from the docks in 2015.

Chapter 10

Fort Burgoyne – Dover

One of the proposals of the 1860 royal commission on the nation's defences was for 'a new work on the high ground to the North of Dover Castle to provide protection to the landward approaches to Dover Castle and give covering fire across the north front of the Western Heights'.

In June 1861, initial work commenced on Castle Hill Fort, designed by Captain Edmund du Cane of the Royal Engineers, with the construction of a set of twenty-seven casemated, bomb-proof barracks on Castle Hill, opposite Dover Castle. The barracks were to accommodate six officers, 217 men and two horses, plus their stores. By 1862 the fort had been renamed Fort Burgoyne in honour of General Sir John Fox Burgoyne, who had been the Inspector-General of Fortifications at the time of the 1860 royal commission. The initial works, which included ramparts, magazines, flanking galleries, four caponiers and the parade ground as well as the barracks, were completed by 1867. The design of the fort represented a five-sided, regular polygon in the shape of a flattened chevron.

Three Haxo casemates had also been constructed on the roof of the fort to accommodate the longer range guns and provide protection for their crews. By 30 June 1868 the expenditure on building the fort had reached £77,716.

These initial works were then supplemented in 1869 by completion of the east and west wing batteries, which projected from either side of the fort. These two batteries were a unique feature of the fort and were designed to provide flanking fire over its approaches. The estimated additional expenditure for these new works was £10,337. When completed in 1873 the fort was designed to mount sixty-eight guns of various types; thirty-five on the terreplein (a fighting platform along the ramparts), twenty-four in the caponiers and gun rooms and nine on the wing batteries.

In 1874 Lt Colonel Jervois, Deputy Director of Works (Fortifications), noted that the fort had transformed the defences on the eastern side of Dover stating, 'so long as it is held an attack is impracticable either upon the castle or along the northern front of the Western Heights'.

Between 1879 and 1881 a stables, laboratory and shifting room were added, but by 1886 other parts of the fort were already considered obsolete and the armament was reduced to just thirty-one guns. The landward-facing Haxo casemates had their gun ports stopped up and by the end of the nineteenth century the trend towards smaller, movable armaments saw many of these 'fixed' artillery positions superseded by machine

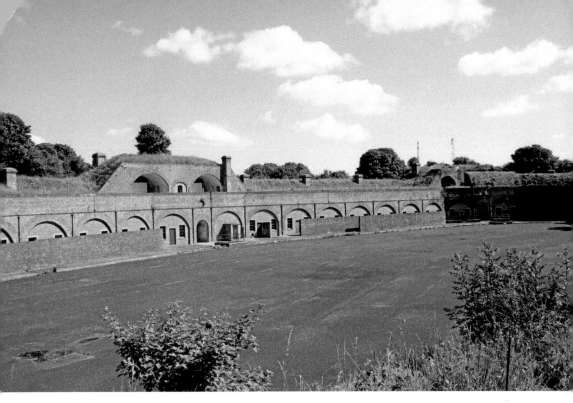

Above: The Parade Ground and Casemates.

Below: The Haxo Gun Casemates.

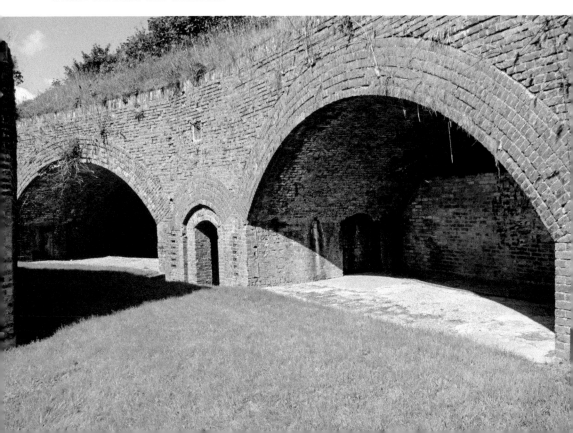

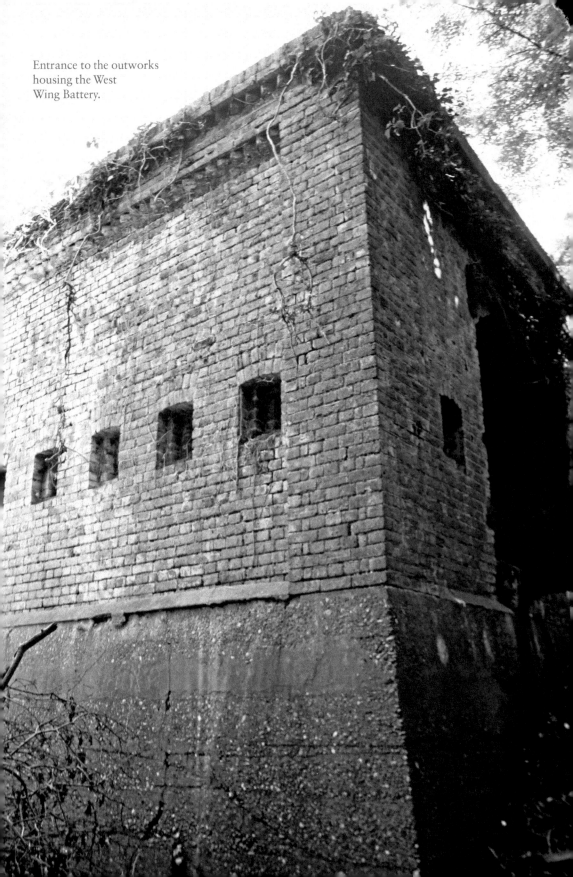

Entrance to the outworks housing the West Wing Battery.

Above: One of the First World War pillboxes on the terreplein of the fort.

Below: One of the Second World War 25-pounder field gun emplacements.

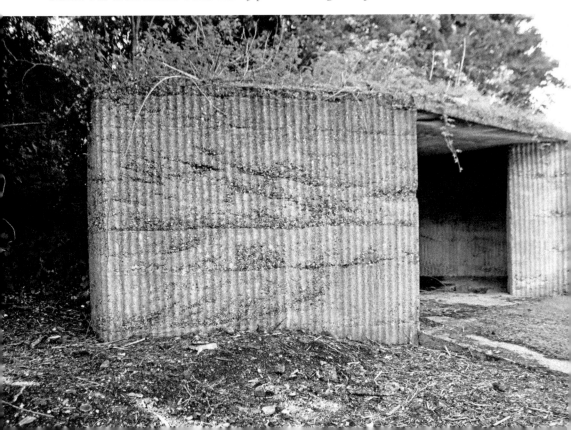

guns and new artillery emplacements to house 12-pounder wheeled field guns. The fort was now considered a more defendable barracks than a static defensive fortification.

In the early twentieth century, Fort Burgoyne continued to be primarily a barracks and played only a minor part in Dover's defences, mounting just a couple of machine guns. In 1912 extra hutted barracks were constructed on a site just to the south of the fort to complement the existing accommodation. This new establishment took the name 'Connaught Barracks'.

Following the outbreak of the First World War, it soon became clear that a new threat to the country had emerged – this time from the air. It was soon realised that Dover was poorly defended against air attack, so a number of anti-aircraft gun sites were built in and around the town, including two mounted in brick-built pillboxes on the terreplein of Fort Burgoyne.

After the war and the consequent reduction in troop numbers, the casemated barracks were turned into storerooms for the newer Connaught Barracks

During the Second World War, Fort Burgoyne formed part of the 'Dover Defence Scheme'. Further modifications were made to the fort's defences, including two new reinforced pillboxes covering the entrance; spigot mortar positions were added and eight new concrete gun houses were constructed on the ramparts for two batteries of the ubiquitous 25-pounder mobile field guns.

With all the extra troops now stationed in Dover, the fort's casemated accommodation provided an ideal overflow for Connaught Barracks. Blast walls were built on the edge of the Parade Ground to protect the troops, stores and ammunition housed in the casemates from enemy air attack.

After the end of the Second World War, Dover continued to be a garrison town. The 1930s Connaught Barracks were demolished in 1962 to be replaced with modern accommodation to serve a professional army. The fort itself was now of little use for military purposes, although the MOD continued to use some of the casemates for stores. Connaught Barracks continued to be used by the Army until 2006 when its last occupants, 1 Para, relocated to Wales.

Fort Burgoyne is now in the hands of the Land Trust, who are busy repairing the neglect it has suffered over recent years and they are looking for opportunities to open it for use by businesses and make it accessible to the local community and visitors.

Chapter 11

St Martin's Battery – Dover

St Martin's Battery, situated off the South Military Road on the Western Heights at Dover, was one of several new coastal batteries built between 1871 and 1882 to counter the threats posed by new armoured warships and their powerful, rifled armaments. Construction of the battery began in December 1874 and was completed by March 1877.

Upon completion, the battery comprised of three gun emplacements, separated by ammunition stores, each containing raised circular gun platforms. Iron rails to convey small ammunition trolleys ran from the stores around each gun pit. The armament consisted of three 10-inch rifled muzzle-loading guns (RMLs) mounted on barbettes, enabling a wide arc of traverse, while the front of each emplacement was protected by a sloping concrete apron.

No. 2 Gun Emplacement.

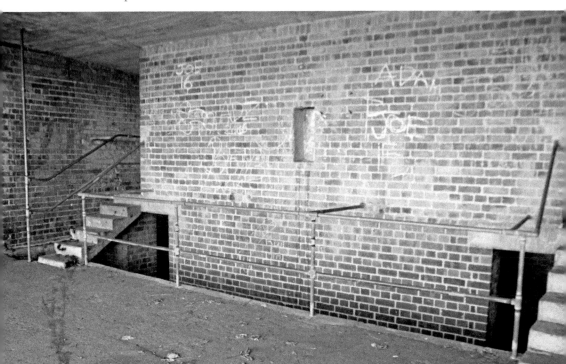

The original main magazine for the battery was situated some distance away on the opposite side of South Military Road and accessed by a tunnel from the Archcliffe Gate, which was the south entrance to the Western Heights fortress. In 1886 it was proposed to remove No. 2 Gun and convert the emplacement into a new cartridge store so more ammunition could be kept closer at hand rather than having to bring it from the remote underground magazine.

However, these proposals never came to fruition as it was thought that the potential benefits of the plan were outweighed by the loss of firepower from the battery, so revised plans were made for a new cartridge store elsewhere on the site. The new magazine was eventually built in 1890 safe underground in the hills to the rear of the battery. Access to the magazine was through a door in the hillside and down a brick-lined sloping tunnel which led to the ammunition stores below.

Between 1893 and 1894 the battery was converted to long-range mountings and the guns adapted for high-angle fire but by 1900 its RML guns were already obsolete. By this time three new batteries had been built at Dover armed with modern breech-loading 6-inch guns. A 1902 report on the available armaments in the Dover area makes no mention of St Martin's guns, so it is possible they had already been removed. Having fallen out of use the battery was decommissioned in 1909 and saw no service in the First World War.

In the Second World War the battery site was revived and designated 'Western Heights Emergency Battery', one of several 'emergency' batteries hurriedly installed along the coast following the fall of France. Work commenced in September 1940 to prepare the site for its guns and was completed in May 1941. The battery's 'new' armament consisted of three 6-inch Mk VII breech-loading guns (BLs) whose manufacture dated from 1899–1903. (However, No.2 Gun, the oldest, was soon removed.) They had been speedily brought back into service from naval storage. They were installed in new covered gun houses built over the old open emplacements, which had been filled in with concrete to create bases for the new guns and protected by brick side walls and concrete roofs.

The new roofs were continued over the rear of the battery to cover new two-storey structures which contained stores for ammunition, and small arms on the lower floors and gun-detachment shelters on the upper. The whole battery was then covered by a

Entrance tunnel to the Victorian Cartridge Stores.

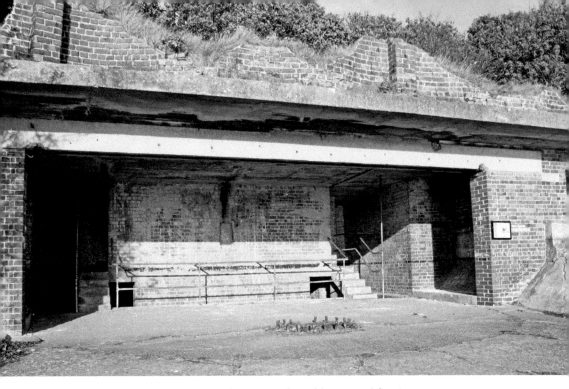

Above: No. 1 Gun Emplacement with its Second World War modifications.

Below: The rear of the battery.

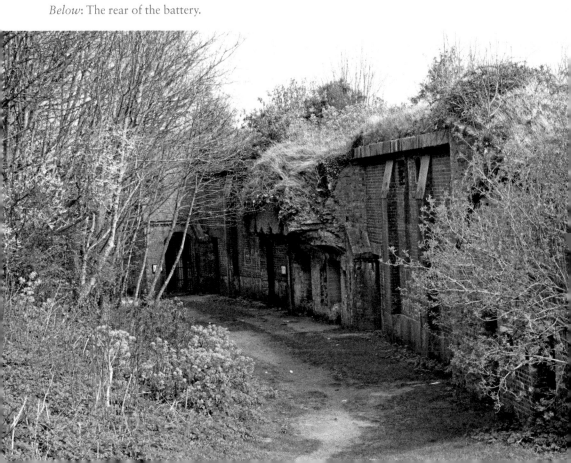

thick layer of earth for protection against bombardment and strafing. Finally, two new pillboxes were added to provide combines infantry and light AA positions with a further light AA post installed on top of the battery. The full complement of this new battery was 143 officers and men.

In 1941, the Royal Engineers of No. 172 Tunnelling Company drove a tunnel from the old 1890 ammunition store further underground to provide a deep shelter large enough to accommodate the full complement of the battery (now designated 414 Coast Battery) in safety. This shelter was completed in March 1941 and gave a floor space of 3,150 square feet. It also included sanitary and medical areas, all beneath a cover of 30 feet of chalk. Access from the rear of battery was via two flights of stairs into the main tunnel, linked to another parallel tunnel by three short chambers. The rear of this tunnel system joined to a straight tunnel, which emerged at an entrance in the blast walls of the nearby Grand Shaft Barracks.

By 1944 the risk of a direct German assault on Dover had diminished enough for the battery to be stood down and placed on 'care and maintenance' basis. The two remaining guns were removed in 1947 and the site was eventually abandoned by the Army in the 1950s.

Today, the battery site (but not the deep shelter) is easily accessible to view and now has a convenient free public car park sited next to it.

The stairway leading down to the Deep Shelter.

Chapter 12

HMS *Pembroke* – Chatham

In 1890 a Royal Naval depot was founded at Chatham. The depot provided accommodation for the crews of warships in the dockyard undergoing refit and repair. The seamen were housed on the hulks of old warships that were moored up in the dockyard's No. 2 Basin. These hulks were crowded and insanitary and totally unsuitable accommodation for the men of a modern, professional navy. To alleviate this situation work began on a new purpose-built, shore-based barracks on the site of Chatham Convict Prison. The prison adjoined the almost complete huge dockyard extension onto St Mary's Island and it had housed the convict labour that had been employed to build the extension over the previous forty-two years.

The barracks site from the air in 2016.

The new barracks were completed in December 1902 and officially opened on 30 July 1903 when the seamen marched, with the Depot Band playing at their head, from the old hulks, out of the dockyard into their brand-new home. In keeping with the practise of the Royal Navy for naming all its shore establishments as if they were ships the new barracks were designated with the name HMS *Pembroke*. The name was taken from one of the old accommodation hulks in the dockyard.

The barracks provided accommodation for 4,700 officers and men, a figure that could be and was more than doubled during wartime. As well as the accommodation blocks the barracks included a drill shed, gunnery school, and indoor swimming baths. In 1906 the building of a new barrack church was completed and dedicated to St George. Another later addition was the gymnasium, which was completed in 1908 and provided a purpose-built indoor facility with the latest gym equipment to keep the servicemen at peak fitness all year around.

By 1910 the Chatham Depot had become the Chatham Port Division, one of the Navy's three principal manning ports. The division was responsible for the manning of 205 ships, over a third of the Navy's strength, and its personnel were responsible for the east coast of Britain, from Scotland to Kent.

The outbreak of the First World War soon saw the barracks full to capacity as reservists were called up and new recruits 'flocked to the colours'. Such was the pressure on the barrack accommodation during the war that the Drill Shed often had to be pressed into service as short-term overflow accommodation for those crews who were about to join their ships.

The accommodation hulk HMS *Pembroke* around 1900.

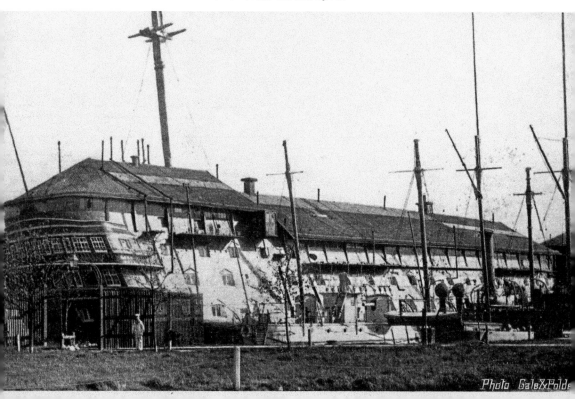

Photo Gale&Polden

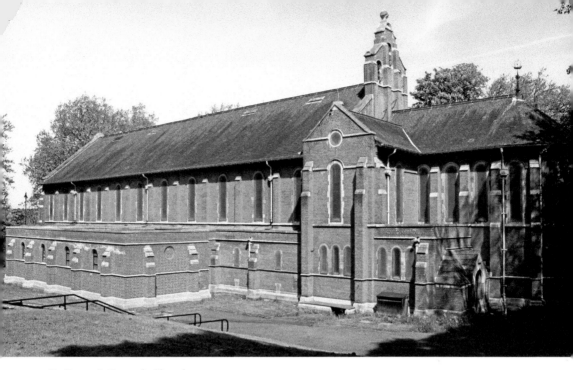

St George's Barrack Church.

On the night of 3 September 1917 there were over 900 men billeted in the Drill Shed. Many of them had been due to join the battleship HMS *Vanguard* but she had suffered a catastrophic accident back in July when an internal explosion had sunk her while she was moored at Scapa Flow. Because of this, her new crew were forced to extend their stay at Chatham while alternative vessels were found for them. That night four German Gotha bombers attacked Gillingham and Chatham. A total of forty-six bombs were dropped on the towns, including one that smashed through the glass roof of the Drill Shed. The roof shattered into thousands of deadly shards, which showered the hundreds of helpless seamen below before exploding on the solid floor. Those that weren't killed or injured in the explosion were cut to shreds by the glass. A total of 136 men were killed and many more injured. As the war drew to a close, further tragedy began to affect HMS *Pembroke*. Between the summer of 1918 and late 1921 the Spanish influenza pandemic swept through the barracks, causing the deaths of 242 men.

The coming of the Second World War once again saw the barracks full to capacity. Eventually a new hutted camp was erected to accommodate the overflow from the main barracks; it was located to the east of the gunnery school on land that had been used as a grazing ground for livestock destined for the nearby Naval Victualling Depot's slaughterhouse. Further additional accommodation was also found in some of the local army barracks. By May 1944 over 17,000 naval personnel were on the ration strength of HMS *Pembroke* and her various annexes.

Following the end of the war, the reduction of the strength of the Royal Navy in its number of ships was matched by that of its personnel. In 1956 the Chatham Port Division was abolished in favour of Central Manning and in 1957 the barracks and gunnery school were closed, although the barracks reverted to use as an accommodation centre for the refitting crews of ships at the dockyard.

The fate of the Chatham naval base was finally sealed in 1981 when its closure was announced in the Government's 1981 Defence Review.

On 3 June 1983 HMS *Pembroke* held its final Ceremonial Divisions and on 29 October that year the last Commanding Officer, Captain Paddy Sheehan, was ceremonially 'hauled out' of the Main Gate by some of his officers and men and the Barracks fell into the care of the Closure Party. On 18 February 1984 the small Barracks' Closure Party gathered at the mast outside the wardroom. The 'Last Post' was sounded by a solitary Royal Marine bugler and the white ensign lowered for the last time. The party left in a horse-drawn brewer's dray cart and the gates of HMS *Pembroke* finally locked.

The site is now owned by the University of Greenwich, which attracts thousands of students from all over the world to study within its historic walls. The public are able to walk around the site but access to the buildings is restricted to staff and students.

The drill shed.

The officers' quarters and wardroom.

Chapter 13

RAF Detling

When the First World War broke out in 1914, military aviation was still very much in its infancy. However, both the Royal Navy and the Army had been quick to realise its potential and both services already had aircraft and trained pilots in service, albeit few in number. The Army's Royal Flying Corps accompanied the Expeditionary Force to France while the Royal Naval Air Service assumed the responsibility for Britain's air defence. Early in 1915, farmland at the top of Detling Hill was chosen by the Directorate of Works as a suitable site for a Royal Naval Air Service airfield. Work began almost immediately and the first aircraft arrived in the June of that year in the form of a detachment of American Curtis aircraft, 3 Wing RNAS, which operated from Detling until they moved to Manston in June 1916.

The airfield then remained unused until April 1917 when the Royal Flying Corps arrived to assume responsibility for the air defence of the Royal Dockyards at Chatham and Sheerness. A number of hangars and other buildings were erected to house the new arrivals. In October 1917, the airfield was the target of a Zeppelin raid for the first time when two bombs were dropped on it by the airship L44, fortunately causing no damage. Various RFC and, later, RAF units operated from Detling until October 1919, when the airfield was abandoned and then put up for sale in 1920.

Following increasing world tensions and the Munich Crisis of 1938, Detling was chosen to be one of the RAF's 'expansion' airfields. In the early years of the Second World War, its main role came during the Battle of Britain when it was used as a satellite airfield by the heavily committed aircraft of 11 Group of Fighter Command, Biggin Hill Sector. Units would use the airfield on an ad hoc basis depending on the daily needs of the battle, returning to their parent airfields at night.

On the 30 May 1940, Corporal Daphne Pearson of the WAAF rescued Pilot Officer David Bond from the burning wreck of his crashed Avro Anson aircraft. In recognition of her bravery she became the first female recipient of the George Cross. Then, on the 13 August that year, the base suffered a devastating Luftwaffe attack in which sixty-seven RAF and civilian staff were killed, including the Station CO, and another ninety-four injured.

The airfield had grass landing surfaces and a number of Blister, Bellman and Bessonneau hangars. It continued to be used by various units of the RAF and Fleet Air Arm operating a number of different aircraft throughout the war, and in October 1943 Detling was designated as No. 125 Airfield of 2nd Tactical Air Force (2 TAF),

The station headquarters converted into a light industrial unit.

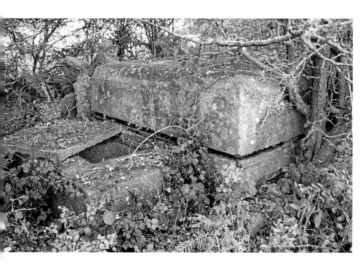

The Airfield Battle Headquarters from where the airfield's defences were controlled when under attack.

accommodating a series of Spitfire squadrons, mainly used for bomber escort work. From June 1944 the Spitfires' operations varied from support for the invasion of France to attacking incoming German V-1 rockets. Some of the Spitfires were fitted with bomb racks and used to attack the V-1 launch sites. During 1945 the airfield also became a base for units of the RAF Regiment.

Following the end of the war, Detling was deemed surplus to flying requirements and reduced to 'care & maintenance' status. The RAF regiment and various army units continued to make use of it, as did various gliding schools until 1956. The base was finally closed down in 1959. Most of the airfield reverted to farmland but the county council took over some of it to use as the Kent county showground. The technical site was turned into a light industrial estate. Most of the buildings were demolished but some survived, including the huge Bellman hangar, which has been reclad and converted into a distribution depot.

However, this was not quite the end of the story as the war had left Detling with a 'legacy' that was to come back to haunt it decades later.

During the war, such was the concern that airfields could be seized by German airborne forces that preparations were made to render those considered vulnerable to such attacks unusable. There were thirty-four such airfields that were well within the range of German transport aircraft and one of them was Detling. These preparations

The sole surviving Blister hangar now used as a farm store.

The converted Bellman hangar.

involved the laying of pipe mines under runways and other airfield areas. Hydraulic rams were used to drive long metal pipes down into the ground at a slight angle until a lattice of them lay around 150 feet in length running between 3 and 6 feet under the surface. These were then filled with the cheapest explosive available, which was usually nitroglycerine-based blasting gelignite. Each pipe was then primed with detonating cord. If an attack proved to be imminent, the ends of the cords could be connected within minutes and the charges detonated. Fortunately, such drastic measures never had to be invoked and after the end of the war Canadian 'sappers' were given the job of clearing the mines from all the airfields. Unfortunately, they did not do a very good job!

Following a fatal accident at Lympne Airfield in 1960, a court of enquiry ordered that new searches be made on all the relevant wartime airfield sites. It was not until

1989 that mines were discovered at Detling, but as it had long been disused and with no immediate danger to any nearby population, it was decided that it was not a priority for clearance. However, some of the affected site was part of what had become Kent County Showground, and that year the Queen was due to open the county show. When someone at the MOD mentioned to palace officials that there were unexploded mines under the surface which the Queen was due to cross, a major 'flap' occurred! The palace demanded 100 per cent assurance from the head scientist of the MOD team involved in clearing the mines that there was zero danger of the mines exploding as the Queen passed over them. He said that there was probably just a million to one chance of this happening, but would not say zero chance. As a result, the royal party was rerouted well away from the 'danger zone' and the mines were eventually removed later that year. This story is based on an account given by Peter Hubbard, who was in charge of the MOD research team involved in the operation, in Anthony J. Moors book *Detling Airfield: A History 1915-1959*.

Today, although much of the airfield's infrastructure has gone, some of the airfield buildings and defensive installations remain. A public footpath runs through much of the site, so viewing these remains is quite easy. The main feature is the large number of pillboxes that are still there; more than can be found in any other single wartime site in Kent.

There are at least fourteen pillboxes that can still be seen and there may be more hidden away in the woods and undergrowth, so it is well worth a visit.

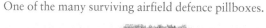

One of the many surviving airfield defence pillboxes.

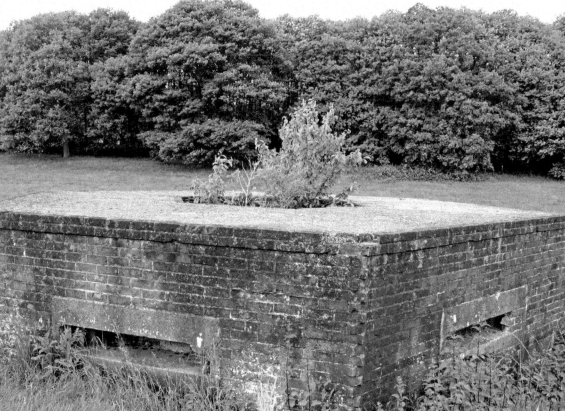

Chapter 14

Shellness Defences

In the early years of the twentieth century, plans were formulated for the defence of the beaches around the Isle of Sheppey, which were deemed to be vulnerable to invasion. Shellness, Harty Ferry, Elmley and Leysdown were considered high risk due to their suitability for landing large forces equipped with supporting artillery.

In 1909, the aviation firm Short Brothers moved to Shellness near Leysdown and created an airfield close to Muswell Manor. Derelict cottages at Shellness hamlet were rebuilt to house the company's employees. However, by the end of the year it had become obvious that the airfield site was prone to waterlogging, so the decision was taken to move the operations a couple of miles up the road to Eastchurch where, in 1910, four naval officers began flying lessons and became Britain's first military pilots.

At the outbreak of the First World War, the defence plans for Sheppey were soon implemented, with the construction of fieldworks extending the length of the island from Sheerness to Shellness. These fieldworks consisted of trenches, machine-gun pillboxes and barbed wire entanglements. The hamlet of Shellness was considered to be particularly at risk from a landing by enemy troops and it became a heavily defended strongpoint. The coastguard station was turned into a 'defended post' with four machine-gun pillboxes protected with sandbags and timber. Barbed wire entanglements surrounded the station and the buildings were 'fortified'.

First World War
machine-gun pillbox.

Prior to the Second World War, Shellness was taken over by the military. Early in the war, an emergency coastal artillery battery was established at the coastguard station armed with two 6-inch breech-loading guns in open-fronted emplacements. The hamlet's buildings provided the battery accommodation and the coastguard lookout was converted into the Battery Observation Post (BOP).

To support the guns, one of the First World War pillboxes was adapted with a concrete ramp to convert it into a base for a mobile searchlight. The hamlet also provided barrack accommodation for the officers of the nearby RAF station at Eastchurch.

The beaches at Shellness were used extensively as a firing range and training ground. There is still live ordnance being found washed up on the beaches today. The ranges were also a testing ground for an experimental rocket system called a 'UP Radiator' (UP stands for unguided projectile) which was used against enemy E-boats operating in the Swale Estuary. Troops undergoing intensive training on the beaches or using the range often had to suffer the additional pressures from attacks by marauding German fighters.

A minefield was also laid across the eastern end of the estuary. No precise details of the layout of the minefield survive, however Dr Richard Walding gives a good indicative explanation of the probable layout on his excellent website (http://indicatorloops.com/shellness.htm):

Typically, a mine loop was 640 yds long by 25 yds wide with four to six buoyant mines moored in the centre and attached to a firing cable. A guard loop is usually 2000 yds x 25 yds wide. The Guard Loop was usually positioned about 1,000 yds on the seaward side of the minefield. Tail cables (4 core) ran from each loop to the shore and thence underground to the XDO Mine Watch Station on the beachfront. The 'L' Mark 2 mine units were the most common being used at that time. They consisted of two 40"

Second World War Battery Observation Post.

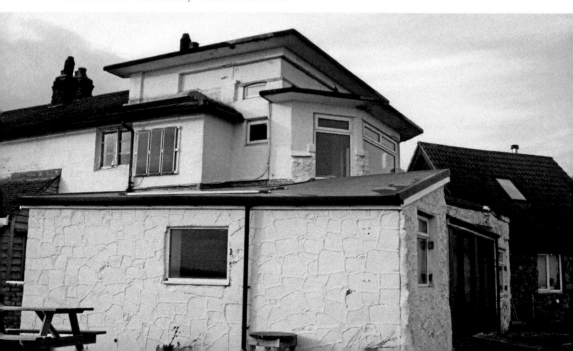

diameter mild steel hemispherical pressings 3/16" thick joined with 1/4" thick bolts. The charge was 500 lb of amatol with an electric detonator (No. 28, Mark 2) inserted into a 1 lb charge of primer. The complete mine and charge weighed 3,151 lb (1430 kg) and could disable a submarine within a radius of 40 feet. They had a positive buoyancy of 468 lb meaning they would float. To keep them moored, a sinker ('L' Mark 2) consisting of a cast iron base with a drum in the centre housing a cable that could moor mines in water up to 25 fathoms deep. Cables used for controlled mining were Admiralty Pattern 660, Pattern 7048 and Pattern 9610 and for tail cables the four-core Pattern 2865/4 was used.

The minefield was controlled from a Mine Watching Station on the beach at Shellness, which was also designated as an Extended Defence Officer's (ExDO) Post. The ExDO was the naval officer in charge of all naval activity in a given area with responsibility for minefields and boom nets. The post building was a pillbox-type structure from which the ExDO could issue instructions to the mine-watching officer on duty. The building can still be seen on the beach. Constructed from reinforced concrete, it consists of an entrance passage, generator room and observation room with a small turret accessible by a long-removed short iron ladder. The two large windows in the walls of the observation room provide excellent views across the East Swale and during the war a Barr & Stroud rangefinder instrument would have been fitted inside to provide precise target location data.

Today the hamlet is a private village, nature reserve and naturist beach and is administered by the Shellness Estate. The ExDO Post is accessible via a walk across the nature reserve and the First World War pillboxes and the Second World War Battery Observation Post, as well as one of the gun positions, can be viewed from a walk along the beach.

The mobile searchlight base.

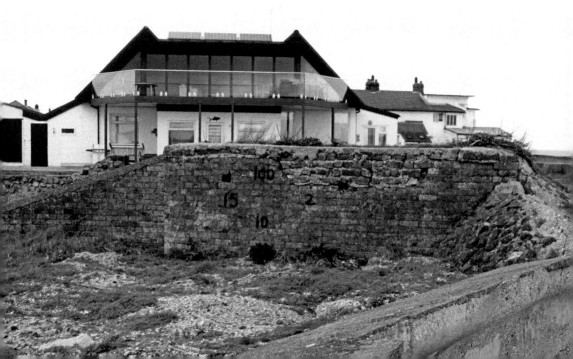

Above: UP rocket storage pit.

Below: The ExDO Post.

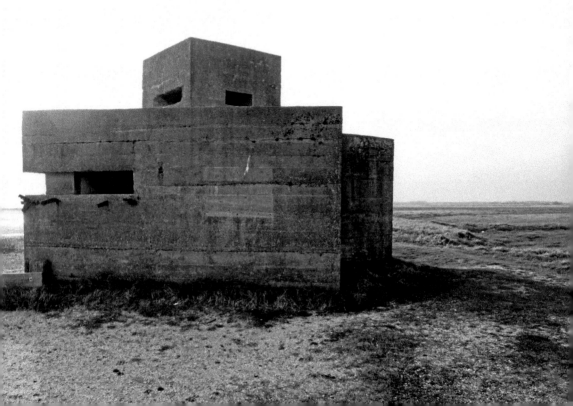

Chapter 15

RAF West Malling

Originally used as an Emergency Landing Ground in the First World War, West Malling was first opened as a private airfield in 1930. In 1933 it was it officially opened as Maidstone Airport. The airport offered flying classes with a Puss Moth, Fox Moth and Gypsy Moth aircraft operating off its grass runway. In 1935 Malling Aviation took ownership of the airfield and renamed it Malling Aero Club.

At the outbreak of the Second World War, the airfield was requisitioned by the RAF and the first fighter squadrons arrived in 1940. It operated as part of the Royal Air Force Fighter Command's crucial 11 Group protecting the south-east and London. On 10 August 1940, while work on constructing the airfield's new buildings was in progress, a single German bomber took the defences by surprise, injuring seventeen builders and killing one. Further heavy air raids on subsequent days caused so much damage that the airfield was put out of operation for most of the period of the Battle of Britain.

Following extensive repairs, the airfield reopened for flying on 30 October 1940. Building work progressed into 1941 and by March that year the work was complete and on 14 April RAF West Malling was officially opened and soon became 11 Group's new night-fighter base.

The night of 16/17 April 1943 saw probably the most famous incident to occur at RAF West Malling during the war. Four German Focke-Wulf 190s, which were attempting to attack London, got lost over Kent. Three of them tried to land at RAF West Malling: Yellow H of 7./SKG 10, flown by Feldwebel Otto Bechtold, landed and was captured; his Fw 190 was later evaluated by the RAE at Farnborough. Another Fw 190 of 5./SKG 10, flown by Leutnant Fritz Sezter, landed several minutes later. When Setzer realised he had landed on an enemy airfield and attempted to take off, his aircraft was destroyed by an armoured car. Setzer surrendered to Wing Commander Peter Townsend. A third Fw 190 undershot the runway and was also destroyed, the pilot escaping with a concussion. The fourth Fw 190 crashed at Staplehurst, killing the pilot.

In 1944 the station was involved in Operation Diver, which was the defence against the V-1 flying bomb attacks. By now, the airfield had two runways constructed from Sommerfeld track-steel matting and concrete, with Type J and Blister design aircraft hangars.

The airfield was closed at the end of August 1944 and underwent considerable refurbishment. A permanent, 6,000 by 150 foot 'hard' runway was laid and the base

Above: One of the barrack blocks displaying the repaired damage from German air attacks.

Below: The sergeants' mess – one of the buildings constructed 1939–41.

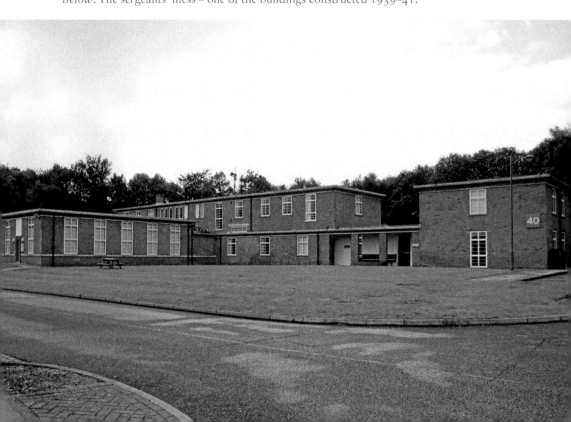

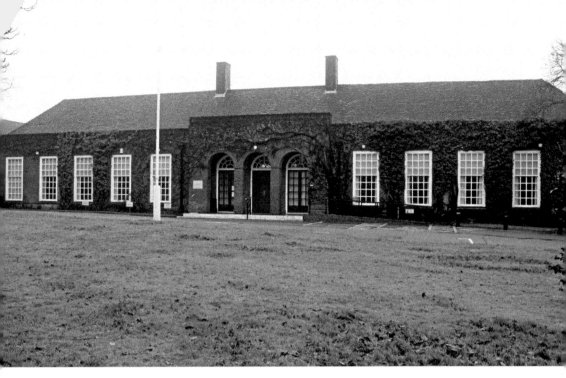

The officers' mess – not completed until 1946.

reopened in June 1945. At the end of the conflict, the base was used as a rehabilitation centre for returning Allied prisoners of war.

Post-war, West Malling remained a fighter base and from 1952 operated jet fighters such as Vampires and Meteors, becoming Britain's 'Premier Night-Fighter Station'. In 1957 RAF Fighter Command announced that West Malling would undergo extensive runway alterations to allow it to operate the latest Javelin fighters. The station was vacated and closed down when work began later that year on resurfacing the runway and perimeter track. Other improvements included the building of a combined Wing Ops/Flying Wing HQ and new married quarters for the officers and airmen. The work was completed in 1959 and RAF West Malling was reformed on 1 August that year. On 5 August, 85 Squadron returned to the station, flying its new Javelin FAW2 fighters.

Just one year later the RAF decided that West Malling was no longer viable as a front-line fighter station and deemed it surplus to their requirements. 85 Squadron left with their Javelins on 8 September 1960 and the station was handed over to the US Navy in a ceremony on 17 October. The *Kent Messenger* reported on the ceremony in its edition of 21 October:

> The American Stars and Stripes and the Royal Air Force Ensign were raised simultaneously at the West Malling Air Station on Monday as the administrative control of the base was handed over to members of the United States Navy. At brief ceremonies in front of the headquarters building, Wing Commander F. N. Brinsden told the assembled officers and men to both the R.A.F. and American Navy that he was gratified by the goodwill, co-operation and patience shown by all concerned with the changeover.

The American Naval Facility Flight at West Malling operated various aircraft in support of US ships serving in British waters. They stayed until 1967, when the airfield was handed back to the RAF only to be immediately placed under 'Care and Maintenance' again. The facilities continued to be used by 618 Squadron RAF Volunteer Gliding Squadron, who had arrived from Manston in 1965, and the aviation firm Short Brothers, who had moved their servicing section there in 1964.

The airfield was bought by Kent County Council in 1970, who wished to control its future development and in 1972 it was used to temporarily house Ugandan Asians who had been expelled from Uganda by its president, Idi Amin.

In mid-1983, the aircraft completion company METAIR moved in. They were engaged in the fitting out of private and executive aircraft to their customers' specifications. A year earlier, the first 'Great Warbirds Air Display' took place at the airfield. The star of the show was a Boeing B-17 Flying Fortress bomber, the *Sally B*. This aircraft had featured in the TV series *We'll Meet Again*. These shows continued every year until 1991. As well as the historical aircraft on display, the RAF also contributed displays by the Red Arrows, a Vulcan bomber and various Tornados, Buccaneers and Harriers. British Airways' Concorde also proved a popular attraction.

By the late 1980s, KCC were looking for developers for the airfield site and chose the US company Rouse Associates to be their partner. The original plans were for a 'high-tech' business park with some low-level industrial units and offices. Some residential development was also envisaged but the emphasis was put on the commercial usage plans with all its attendant benefits for local employment. However, the recession

The re-furbished Control Tower in 2015.

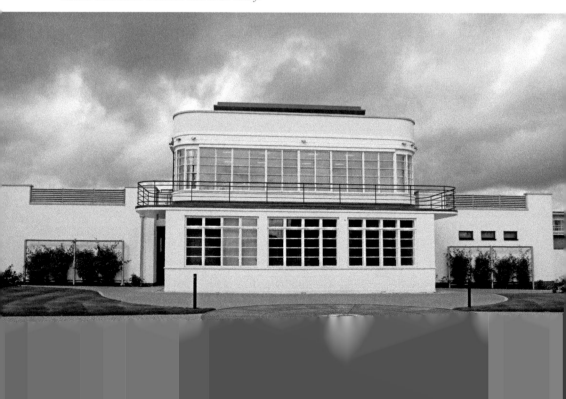

of the early 1990s saw the emphasis move away from the commercial to the residential development of the site. None of these plans included any continued use of the airfield for flying and by the mid-1990s METAIR and the gliding school had left and the runway demolished.

The site is now a major residential area, the parish of Kings Hill, with some offices, shops and leisure facilities. The old airfield domestic site remains almost intact with the barrack blocks being used as offices and the officers' mess in use by Tonbridge & Malling Borough Council and the police. The old control tower has been completely refurbished and turned into a coffee bar and offices.

Most of the other airfield buildings have been demolished but some pillboxes, the remains of some shelters and a Bofors anti-aircraft gun/observation tower can still be found on the outskirts of the site.

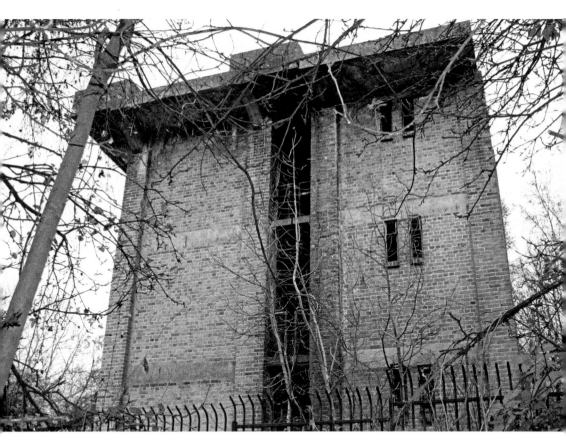

The Bofors anti-aircraft tower.

Chapter 16

St Margaret's Battery

After the fall of France to the Nazi blitzkrieg in 1940, the Germans soon began to build up forces in the Channel ports ready for an invasion of Britain. The British coastal artillery defences were very weak, so an emergency programme of work was initiated to update existing batteries and build new batteries along the coastline. One of the first of these new batteries was built in the summer of 1940 on the cliffs above St Margaret's Bay near Dover. This area of the Kent coast was considered particularly vulnerable to invasion due to its proximity to occupied France.

The battery was armed with four 5.5-inch naval guns that had been removed from the secondary armament of the battlecruiser HMS *Hood*, which had been replaced during her refit the previous May. The guns were installed in four reinforced, concrete gun houses sited along the clifftop. The battery was manned by the four officers and 165 other ranks of 411 Battery, part of 540 Coast Regiment, Royal Artillery. The battery's main anti-aircraft defence was provided by unrotated projectiles (UPs) known as 'Z' rockets. The Z rockets were not a very accurate weapon but the thinking was that if they were fired off in large enough quantities, at least one would get lucky and hit an enemy aircraft!

At the rear of the four gun emplacements men of 172 Tunnelling Company, Royal Engineers dug out a deep shelter to an average depth of 60 feet to provide safe

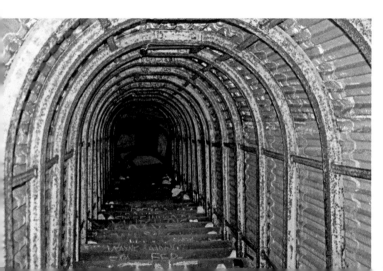

One of the entrance stairways down to the shelter.

accommodation for the crews in the event of the battery being shelled or bombed. The shelter had three entrances – two behind the guns and a third near the cliff edge.

The first two entrances led down stairways to two roughly parallel tunnels linked by four cross-tunnels, one of which was built as an addition to the original plan. It was constructed slightly wider than the other cross-tunnels so as to provide sufficient space for it to be used as a medical dressing station.

The tunnels and stairways are lined with corrugated, galvanised-steel sheeting supported by steel colliery hooped girders. The tunnels were also additionally lined with timber and plywood, most of which has now rotted away though a few traces can still be seen. The floors were levelled with a 4-inch screed of sharp sand and cement. When completed, the shelter offered a total floor space of 3,480 square feet and could provide protection for the battery's entire complement of 169 officers and men.

A long, unlined tunnel leads from the shelter to a hole in the cliff face. It's thought that this hole was used by the tunnellers to remove the spoil from the tunnels as they were digging them out.

From this point, another unlined shaft leads to the third entrance, which is thought also served as the emergency exit for the shelter.

The battery's guns had only a limited range of less than 18,000 yards, making them fairly ineffectual for their purpose of shelling enemy ships out in the Channel, and it was soon made redundant when the new battery at nearby Fan Bay, with its more powerful 6-inch guns, came into operation in April 1941.

One of the shelter's main tunnels.

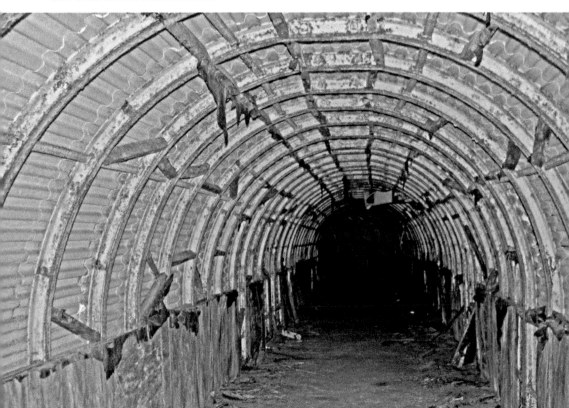

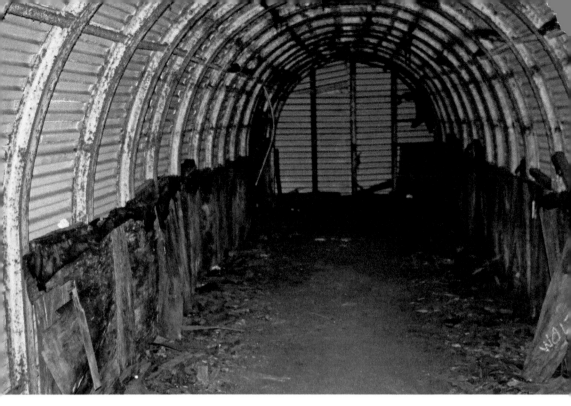

Above: One of the shelter's cross-tunnels.

Below: The unlined tunnel.

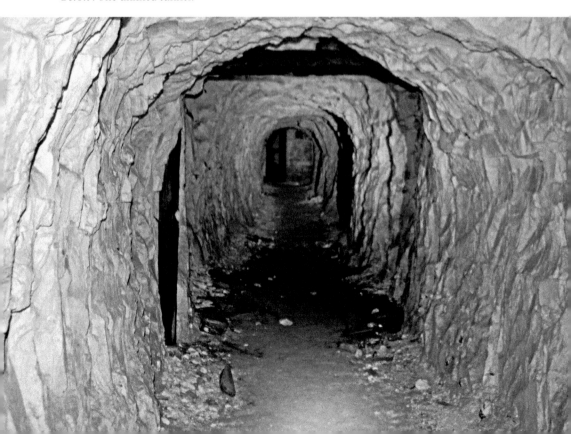

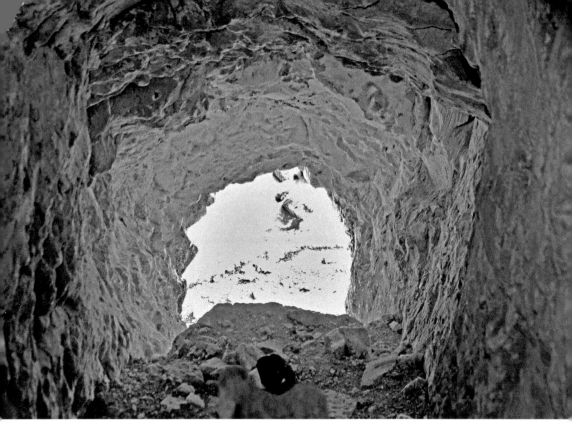

The hole in the cliff face where the spoil from the tunnel digging was ejected.

Thereafter, St Margaret's became a training battery and later in the war it was converted into a 'flashing' battery. When enemy shipping was spotted out in the Channel the guns would be loaded with special charges, which produced a bright muzzle flash when fired. This deceived the enemy into thinking they were coming under fire from heavier guns, causing them to change course and then come into range of the genuine heavy four 9.2-inch guns of South Foreland Battery and the two 15-inch guns at Wanstone Farm Battery.

The battery fell out of use after the war and in the 1970s, in common with most of the other coastal gun sites in the Dover area, the gun houses and all other surface structures were demolished, leaving just the deep shelter as the only trace left behind. However, access to this was restricted, with the two main shelter entrances behind the guns being completely sealed up with spoil from the demolition of the concrete gun houses. The shelter itself too could soon disappear due to its position near to the cliff's edge and the constant erosion that occurs here.

The tunnels today remain in fairly good condition despite the inevitable vandalism and graffiti that's occurred over the years. The access stairways from the two main entrances are strewn with rubble and other rubbish but otherwise the tunnel floors are clear. Even now though descent into the tunnels is not advised as the cliff erosion has already exposed again the gaping hole into the cliff face at the bottom of the remaining access shaft and the entrance to the shaft has been barred as a safety precaution.

Chapter 17

River Medway GHQ Line

Following the evacuation of British forces from Dunkirk and the fall of France in the early summer of 1940, concerns quickly turned to the anti-invasion defences of the United Kingdom. With most of the Army's heavy equipment abandoned in France, its immediate ability to prevent any major German assault was severely curtailed. An additional concern was that the nation's existing static defences were outdated and woefully inadequate to deal with a seaborne invasion. It was obvious that this critical situation had to be addressed with some urgency.

General Sir William Edmund Ironside, Commander-in-Chief, General Headquarters (GHQ) Home Forces had the unenviable task of preparing Britain's anti-invasion defences. To aid his task, he was given additional powers and made chairman of the Home Defence Executive, which enabled him to communicate direct with Government departments.

Ironside drew up a plan of defence, which was submitted to the War Cabinet on 25 June 1940. Among the plan's proposals were for the inland areas to be divided into zones consisting of a series of 'stop' lines. The most important of these zones was to be the one that encompassed London. The 'stop' lines were to be selected by the General HQ Home Forces were designated GHQ Lines or more familiarly as the 'Ironside Line'. The lines consisted of anti-tank obstacles, pillboxes, barbed wire entanglements, static anti-tank gun emplacements and, where suitable, mines. It was also deemed necessary that the fullest use be made of natural obstacles such as waterways. Bridge crossings in particular were to be heavily defended and prepared with demolition charges to prevent their use by the enemy.

The River Medway was an obvious choice for a 'stop' line. The lower reaches of the river were already well defended with the static fortifications of the Chatham Lines, along with the ring forts built in previous eras to defend the royal dockyard at Chatham, but even these needed extensive strengthening and modernisation with new pillboxes, minefields and hundreds of roadblocks. Further improvements were made on the Hoo side of the river with the building of pillboxes and anti-tank defences both along the river and extending further inland.

Moving upriver from Rochester to Ashurst and beyond into Sussex, there was little in the way of defences in place, so there was intense construction activity as hundreds of pillboxes, anti-tank ditches and obstacles were hurriedly built along the Medway.

The main activity was concentrated on the left bank with the river itself providing a natural barrier to any enemy forces advancing inland from the channel coast. Most of the building work was undertaken by local construction companies under supervision of the Royal Engineers. The pillboxes were built to various standard War Office designs or 'types', with some variants, to accommodate either infantry, machine-gun or anti-tank roles. Unfortunately, some were built too close to the river and were prone to flooding, meaning they were abandoned fairly quickly.

Along the river, GHQ identified a number of 'defended localities', which were to be made into heavily defended strongpoints. These areas included Teston, Allington, Aylesford, Tonbridge and Penshurst. The county town, Maidstone, was designated as a fortress with the town centre turned into its 'keep' – a heavily defended final redoubt that was to be held to the proverbial last man!

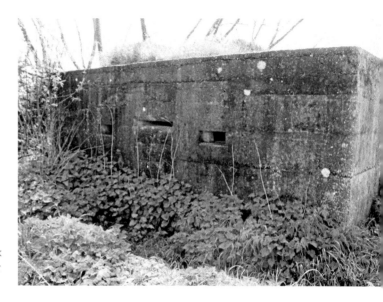

A 'Type 24' infantry pillbox alongside the Medway near Tonbridge.

Anti-Tank 'Cube' obstacles by the Medway at Maidstone.

Upriver from Maidstone at Teston, the lock and the medieval bridge were considered vulnerable to exploitation by an advancing German force. In addition, any successful crossing of the river here would offer the immediate reward of access to the A26 Maidstone to Tonbridge trunk road and the Medway Valley railway main line. Just a couple of miles to the north lay the even more tempting prize of the RAF airfield at West Malling.

Taking all this into consideration, it is no surprise that this crossing area was heavily defended by no fewer than six pillboxes and a number of anti-tank obstacles and infantry trenches. On the south bank of the river, there were two shell-proofed machine-gun pillboxes and on the north side, set back between the railway line, were two infantry and two anti-tank gun pillboxes, all of which still survive today.

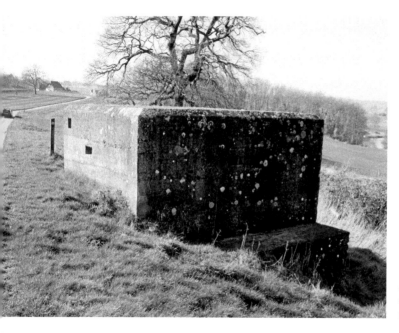

A machine-gun pillbox on the south bank of the Medway at Teston.

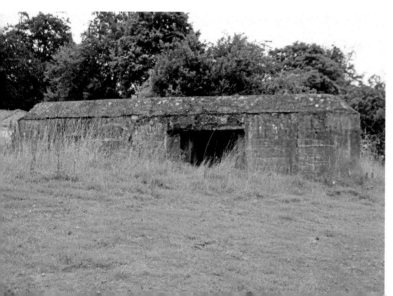

A 'Type 28A' anti-tank pillbox on the north bank of the Medway at Teston.

Downriver at Aylesford, the river and railway line converged again. Here, a large combined anti-tank gun and infantry pillbox defended the southerly road approach to both the railway and another medieval river bridge. Nearby, adjacent to the level crossing here, was an oil depot, which was an obvious target for air attacks. To counter these attacks, a pre-fabricated version of a 'Type 23' anti-aircraft pillbox was erected on the depot's riverside quay. It had a mounting for either a Lewis or Bren machine gun, housed in an open-roofed annexe of the pillbox, which enabled the gun to be elevated for use against low-flying fighter-bombers. There are also some improvised defensive features to be found in the village. One of the houses that backs on to the river has a 'loopholed' wall with embrasures for a machine gun and rifles overlooking the bridge. Another house has an outbuilding converted into a defence post with an embrasure for a light anti-tank gun that would cover most of the High Street.

Much of the 'GHQ Line' remains in evidence to this day and if you take walk along any of the many public footpaths that run alongside the River Medway you will see numerous pillboxes and even the occasional anti-tank obstacle. The pillboxes were certainly built to last and some have been listed, which will ensure they will remain as a testament to future generations of those dark and dangerous days of 1940 when Britain stood alone ready to face the onslaught.

The 'Defended Building' in Aylesford High Street.

Chapter 18

South Foreland Battery – St Margarets-at-Cliffe

Occupying a key position on the white cliffs of Dover, South Foreland Battery was a Second World War coastal gun battery. Construction of the site commenced on 28 December 1940 and was completed by 28 November 1941. The civilian construction company R. Costains was the major contractor for the surface buildings. It was the largest of batteries built by the Royal Engineers in the Dover Area during the Second World War.

The battery consisted of four 9.2-inch guns, each with a range of over 36,000 yards, mounted in emplacements that had been cleverly camouflaged with the aid of specially planted hedgerows and trees and surrounded by decorative white chain-linked fences so as to make them appear as gardens from the air. No.1 and No.4 guns each had their own underground magazines whilst No.2 and No.3 guns shared a huge surface magazine. This twin-domed structure was protected by a very thick concrete cap and several feet of earth.

An underground battery plotting room tracked targets for the guns and two large engine houses powered their operation. As well as the gun emplacements and magazines,

The surface magazine and shell store for No. 2 and No. 3 Guns.

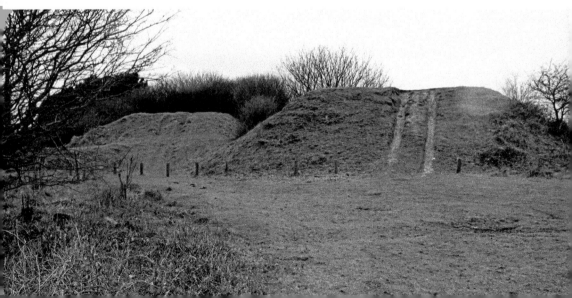

there were all the ancillary structures associated with a battery of this size: a guardhouse, messes, dining rooms, a cookhouse, latrines, ablutions, offices, stores and workshops.

Underground accommodation for all the battery personnel was provided in a deep shelter which also offered them protection from enemy air-raids and shelling. The shelter was excavated by men from 172 Tunnelling Company, Royal Engineers. Access to the shelter was by any of three protected stairway entrances. The long stairways led to two parallel tunnels, each one 150 feet in length. These two tunnels were connected by three chambers which provided the sleeping accommodation and medical facilities.

The battery was designated as 290 Coast Defence Battery and was manned by men from 540 Coast Regiment, Royal Artillery whose Regimental Headquarters was established on the same site beside the South Foreland Lighthouse. The regiment was also responsible for manning the nearby batteries at Fan Bay (three 6-inch guns) and Wanstone Farm (two 15-inch guns). The three batteries were together designated as a 'fortress' and an underground fortress plotting room was sited close to the lighthouse to co-ordinate and allocate targets to the three batteries according to their different ranges.

The Regimental HQ and fortress plotting room staff also shared a nearby underground deep shelter. Another fortress installation was the Coastal Defence/Chain Home Low (CD/CHL) radar set, which enabled the tracking of enemy vessels of 750 tons and over. The radar set was also capable of detecting the fall of shot from the guns by following the line of the shell and picking up the splash as it fell into the sea. This information was vital to the battery commander, enabling him to order correction to the guns to compensate for the shot falling off-target.

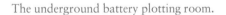

The underground battery plotting room.

South Foreland Battery's main purpose was to deny passage of the English Channel to enemy shipping. It underwent its greatest test on 12 February 1942, when three of Germany's most powerful warships, *Scharnhorst*, *Gneisenau* and *Prince Eugen*, broke out from the port of Brest on the exposed French Atlantic coast with an escort of several smaller vessels and submarines under Luftwaffe air cover. Their aim was to force a passage through the Channel to reach the safety of German ports. Although the British were expecting such a breakout, they presumed it would be carried out under the cover of darkness, so when the radar set at South Foreland first began tracking the ships around noon, most of the Channel defences had already been taken completely by surprise. Six RAF Swordfish torpedo-bombers were scrambled from RAF Manston to intercept the convoy but were all shot down by the Luftwaffe escort. South Foreland's guns had not long been installed and their crews were still undergoing training, but they had enough warning to prepare and load. The battery fired thirty-three rounds over a period of seventeen minutes but the German vessels continued their passage relatively unscathed. This daring German operation became known as the 'Channel Dash' and was considered a huge British failure of arms.

The Regimental HQ site near the lighthouse was almost completely demolished after the war but there is still plenty to see at the publicly accessible battery site at South Foreland, including the surface magazines and plotting rooms. Although securely gated and locked, access to some of the underground rooms is also possible by contacting local keyholders whose telephone numbers can be found posted on the gates. However, great care should be taken when accessing these underground rooms. Correct safety clothing and footwear should be worn and a decent torch (with a backup) will be needed. A final word of warning – as with any underground site you should never attempt to enter them alone.

Engine House.

Above: The entrance to the underground fortress plotting room.

Below: The Regimental HQ Deep Shelter.

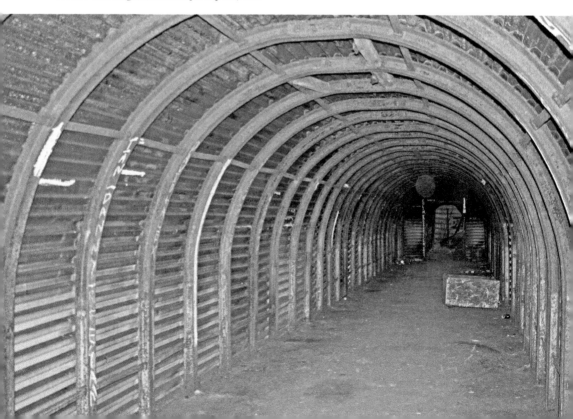

Chapter 19

Red Sand Sea Fort –
Thames Estuary

Red Sand Fort is one of three forts located in the Thames Estuary and manned by the Army in the Second World War (the other two being Shivering Sands Fort and Nore Fort). They were designed as platforms for anti-aircraft guns and the layout mimics that of a land-based heavy anti-aircraft gun battery. Their original purpose was to combat the German minelaying aircraft that had been creating havoc with shipping in the estuary since the outbreak of the war.

The forts were designed by Guy Anson Maunsell, a British civil engineer, and constructed in 1941–42 at the W. T. Henley Red Lion Wharf site in Gravesend. The towers were towed out to their positions and lowered by handwinch onto the sea bed. Their four, hollow, reinforced-concrete legs were then secured on a submerged reinforced-concrete base. The legs were 65 feet high with an external diameter of 3 feet and an internal diameter of 2 feet. The four legs supported a steel, two-storey octagonal 'house', which provided accommodation and storage facilities for the fort's establishment, while the roof deck acted as a gun platform.

Each fort consisted of seven towers linked by steel catwalks. One tower was armed with two 40-mm Bofors guns and four towers mounted single 3.7-inch heavy anti-aircraft guns. Of the other two towers, one was a searchlight tower and the other was the Control Tower, which housed the radar and predictors. Five of the towers were fitted with mooring facilities, thus enabling the unloading of supply ships under most conditions. Every tower had its own boiler, which supplied the heating and hot fresh water. The toilets, baths and washrooms used hot and cold salt water.

When construction of the towers was completed, they were loaded onto lighters and towed downriver by tugs from Gravesend to their respective sites. On arrival at their final destinations, the towers were lowered into their positions onto the sea bed by hand winch.

The crew initially numbered 165 men but this was increased to 265 after June 1944 to counter the V-1 flying bomb threat. They spent four to six weeks on board followed by ten days break ashore, of which just two were normally allowed for home leave while the rest had to be spent at Gillingham Drill Hall. During the course of the war, the three forts shot down twenty-two aircraft and around thirty V-1 flying bombs or 'Doodlebugs' between them.

After the end of the war, the forts were placed under 'care and maintenance' and manned by specialised civilian units to undertake these tasks. With the outbreak of the

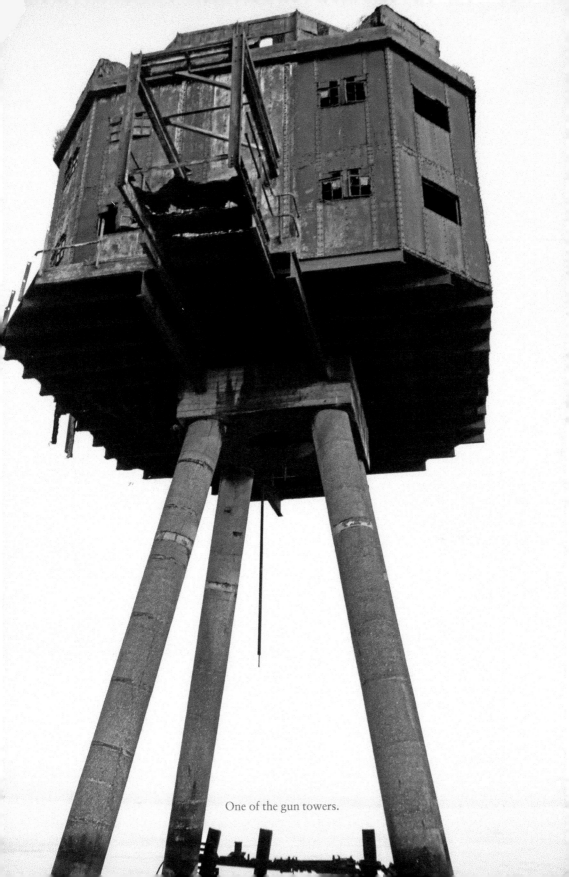

One of the gun towers.

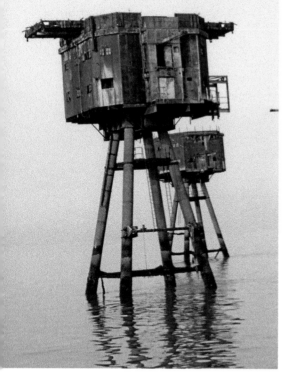 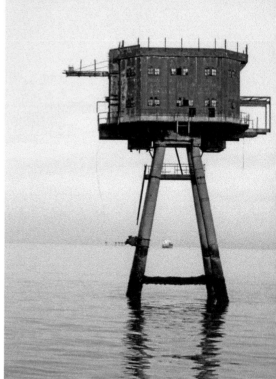

Above left: The Bofors tower.

Above right: The searchlight tower.

Korean War in 1950 the forts were refurbished and new equipment installed, but they were never fully recommissioned. In 1953 Nore Fort suffered severe damage when a Swedish ship collided with it in thick fog, destroying two of its towers and killing four of the civilian maintenance crew. In 1956 the forts were divested of all of their guns and most of their equipment and abandoned. The ruins of Nore Fort continued to be considered a danger to shipping and it was finally demolished in 1960.

Shivering Sands Fort lost one of its 3.7-inch gun towers in 1963 when it was the victim of another ship collision, but at least it was put to use the following year when its searchlight tower was converted into a weather monitoring station.

A new use was found for the forts in the mid-1960s when they were occupied by various 'pirate' radio stations until a change in the law in 1967 forced them off-air. In the 1970s, to prevent any illegal reoccupation, the catwalks and access ladders were all removed and the forts left to slowly decay, although they were still occasionally used by Special Forces for simulated oil-rig assault training. Several television companies have also made use of the forts with episodes of many famous series being filmed on them, including *Danger Man*, *Doctor Who* and *Lovejoy*.

In 2003, Project Redsand was formed to secure the future of the one remaining complete fort, Red Sand, which is situated approximately 6 miles off Minster on the Isle

of Sheppey. Surveys were undertaken to determine the structural stability of the towers and work was undertaken to address the reported concerns that resulted from the surveys. The project has been aided by many donations and a very enthusiastic team of hard-working volunteers make regular visits to the fort to continue with its restoration.

Possible future uses for the fort's towers include recording studios, communications platforms, weddings and corporate hospitality tours. Meanwhile, some charter boat services offer trips out to cruise around the remaining forts – an experience I can thoroughly recommend as a great way to get up close to these now iconic structures.

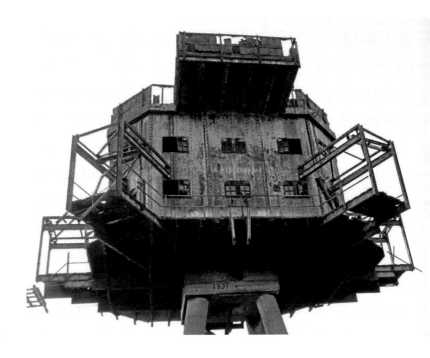

The control tower.

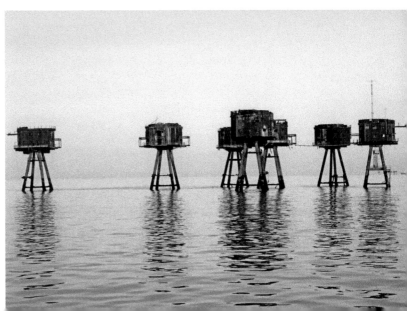

Red Sand Fort
in 2015.

Chapter 20

Dover Castle Combined HQ/Regional Seat of Government

In the Second World War, tunnel complexes were excavated under Dover Castle to house a new forward combined headquarters for all three military services. The tunnelling was carried out by 172 Tunnelling Company and 693 Artisan Works Company of the Royal Engineers. The new CHQ was named 'Bastion'. Work commenced in early 1941 to extend the existing underground complex. The new tunnels were dug above and to the rear of Admiralty Casemate Level and were over half completed when the work had to be abandoned due to severe subsidence.

In late 1942, the work recommenced but at a much lower level, excavating a new complex of tunnels and rooms. Spoil from the works was tipped out through a hole made in the cliff face. After the tunnellers had finished their work, they were followed by about 250 tradesmen of No. 693 AW Company, Royal Engineers. They included masons, plumbers, bricklayers, electricians and plumbers. By early 1943 this work was completed and the complex had been fitted out to form a complete joint headquarters designated 'CHQ Level'. It was fully equipped with a back-up power generator and an air-conditioning system. Written communications within the complex were made by the use of a Lamson vacuum-tube system. The new HQ was connected, by telephone, via a huge network of cables to the various coastal gun and anti-aircraft gun batteries, brigade HQs, airfields and naval establishments in the Dover area.

Security of the CHQ was always a major concern. Military police from all three services controlled the entrances to the underground tunnel complex and armed Army

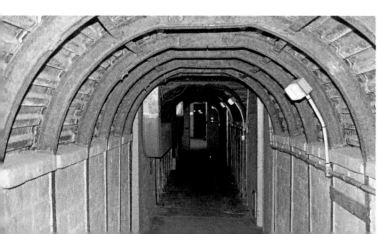

One of the tunnels showing the 1943 construction with colliery hoops supporting the corrugated metal sheeting that lined the tunnels.

guards continuously patrolled the perimeter of the castle. The security measures were put to the test in late 1943, when a small group of armed commandos burst in to one of the communications rooms, surprising the radio operators and forcing them to stand facing the wall while they rampaged through the complex. They had gained access to the tunnels by scaling the spoil heap that had been formed down the cliff face by the tunnel excavations and entering through a ventilation shaft. This major failure in security was made good and no mention of the embarrassing mock attack was ever made again.

After the war the CHQ was closed and the tunnels were cleared of most of the equipment and furniture. However, the increase in the tensions of the Cold War following the Berlin Crisis of 1948 saw the reactivation and updating of some of the country's wartime radar stations and an Anti-Aircraft Operations Room (AAOR) was opened in the former CHQ complex to co-ordinate with the Ground Control Intercept Radar Station at Sandwich. New blast-proof steel doors were installed at the entrances and exits and steel plates were fixed to the grills of the ventilation shafts for added protection. The AAOR continued in use until the Army's Anti-Aircraft Command was disbanded in 1955.

When the garrison vacated the castle in 1958, the tunnels fell into disuse until 1962 when they were handed over to the Home Office for adaptation into one of ten new proposed Regional Seats of Government in England and designated RSG 12. Its purpose was to provide secure accommodation for senior ministers as well as a system of administration

Some of the communication equipment packed up for distribution to other museums.

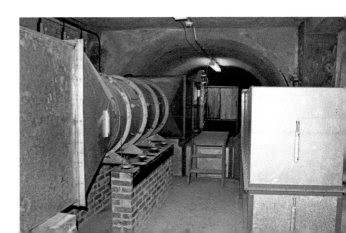

Ventilation plant.

and supply during and following a nuclear attack. The lowest tier of tunnels, now designated 'Dumpy Level', became the communications and operations centre and housed the various government departments. 'Dumpy' was modernised and fitted out with new communications equipment, modern air-filtration plants and generators.

A complete BBC studio was also installed to enable radio broadcasts to be made to those who had survived the initial nuclear assault above ground. The main access was via a lift from a new, purpose-built entrance block near the officers' mess which was faced with stone so as to blend in with its far older surroundings. The higher tunnel levels were used as stores and a canteen and were also fitted out with new dormitories, rest rooms and kitchens. Although the new RSG was meant to be top secret, its existence inevitably soon became known to many of the local Dover residents!

Before this refurbishment had been completed, the system for emergency government was changed again with the creation twenty-five Sub-Regional Headquarters (SRHQs) and reorganised once again in 1972 with fewer SRHQs. Dover was designated as SRHQ 6.1 and remained in use until the late 1970s when, just as yet more new work was due to start, the decision was taken to move operations to a Regional Government Headquarters at Crowborough in East Sussex.

The Home Office finally abandoned the Dover tunnels in 1986 and handed them over to English Heritage. The upper levels (Annex and Casemate) have been opened to the public for some years now but 'Dumpy' remains off-limits due to health and safety concerns, except for occasional, specially organised small group visits.

Conference room.

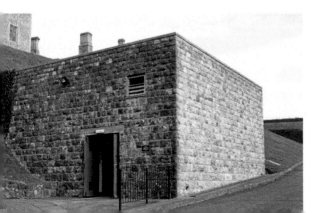

Main entrance block.